p a i n t i n g

LANDSCAPES

f r o m y o u r

IMAGINATION

b y T o n y S m i b e r t

A "FOLD OUT AND FOLLOW ME" PROJECT BOOK

International Artist Publishing, Inc
2775 Old Highway 40
PO Box 1450
Verdi, Nevada 89439

© Tony Smibert/International Artist Publishing, Inc

Concept and Design by Vincent Miller
Edited by Terri Dodd
Photography by John Smibert
Typeset by Andrew Forbes

Printed in Hong Kong

National Library of Australia
Cataloging-in-Publication Data

Smibert, Tony
Painting Landscapes From Your Imagination

ISBN NO: 1-929834-02-0

First published 1997
Second printing in softcover 2000

Distributed to the trade and art markets in North America by
North Light Books,
an imprint of F&W Publications, Inc.
1507 Dana Avenue
Cincinnati, OH 45207
(800) 289-0963

ACKNOWLEDGMENTS

Without the constant support of my wife, Carmel, and children Olivia and Grace, this book would never have been completed. Our studio is a family concern and the most important person in the whole project has been my Dad, John Smibert, who photographed all of the demonstration sequences and most of the other studio shots. After a lifetime in the photographic industry he thought he had retired to a quiet rural setting, but has been swept up into project after project. Thanks Dad, for your patience, support and expertise. Don't expect to retire yet!

Along the way I was encouraged and assisted by professionals in all sorts of areas. I particularly need to thank Terry and Donna Warren of Artery in Hobart, and Kelvin Smibert of Blue Lake Papers in Mt.Gambier, for their support and practical advice. Special thanks must go to my cousin Anne and "honorary cousin" Hugh Mackinnon of Mountford Granary Art School who have supported and encouraged me in so many ways over the years, and to Graham Young and Janell Price.

Terri Dodd, who has patiently assisted me through this and many other projects, has been fantastic to work with. Her top-class editorial skills are only equalled by her neverending patience and goodwill.

But the greatest thanks should go to Vincent Miller, without whose vision, encouragement and professional wisdom this book would never have happened. Friendship and business can go hand in hand.

I dedicate this book to Olivia and Grace.

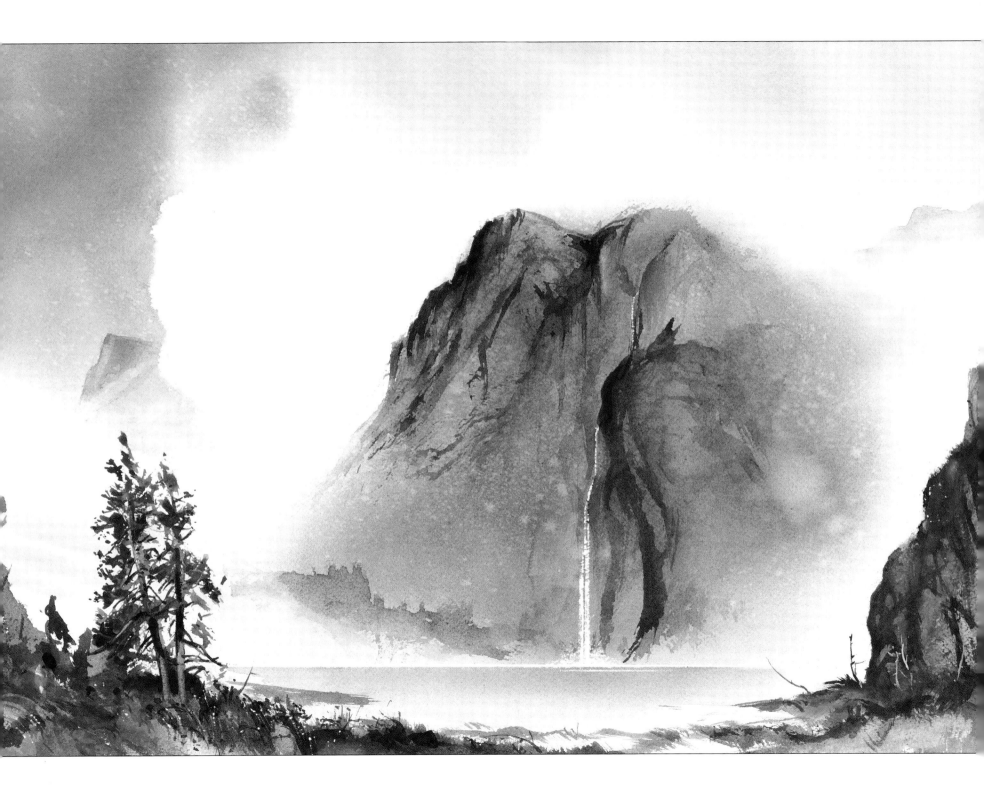

TABLE OF CONTENTS

4

PART IV: THE PROJECTS

HERE'S HOW TO SEE THE FINISHED PAINTINGS AS YOU FOLLOW EACH PROJECT

1 **Choose your project**
Look for the reproduction of the relevant project on the fold out page inside the back cover of this book. Each project is named with the title of the painting.

2 **Fold out the finished painting**
Carefully fold out the page so you are able to view the finished painting while turning pages of the chapter.

3 **Follow the stages to recreate the project**
As you follow the step-by-step project, you can instantly refer to the folded out painting to see what stage you are at, what to do, and what comes next.

INTRODUCTION

Anyone can create original watercolors

This book is designed to help you create original landscapes from your own imagination. It starts with a short introduction to watercolor painting, materials and equipment; goes on to show you how you can learn from watercolor itself, and then teaches you how to use the characteristics of the medium to kick-start your imagination.

If you are afraid you are not making full use of your imagination, or you fear that you'll never fully realize your creative potential then perhaps this book will help.

Even though as a professional painter I now totally depend on my creative abilities, there was a time when I didn't seem to have many original ideas for pictures. I remember at art school comparing myself to the many gifted people I saw all around — people who always seemed to know what they were going to paint even before they began. I was so convinced that I lacked the imagination to be a real artist that I even gave up painting for some years, although I knew in my heart that one day I would find a way to pursue my love of art.

Years later, I attended a workshop in watercolor and began to study painting

seriously. It only took one wash to convince me that this was something different! Watercolor is a creative medium. When a watercolor emerges from the wash, it does so imbued with possibilities. And I could see the possibilities! That was the key to starting to paint from my imagination and discovering a level of creativity buried deep inside myself that I really had not known existed. I've coined a phrase for this: my "Inner Artist" — a potential for art that I had never managed to tap before.

This book is built on the premise that anyone is capable of creating original watercolors, in this case landscapes, but the same applies to flower paintings, abstracts, and many other subjects. The goal is to learn how to view the medium as your collaborator, rather than as a servant — a collaborator which will help you all along the way with creative possibilities, because creative watercolor is about seeing the possibilities inherent in every wash and mark.

The best way to begin is to look at how watercolor works and then embark on a short introductory or refresher course in watercolor technique (both of which you'll find here). These

are important preliminaries to painting watercolor landscapes entirely from your imagination. Of course, if you already know how to paint in watercolor then you're half-way there.

Eventually, you won't have to paint that view out the window again just because it's the only landscape you can see from your studio. Freed from the necessity to have your subject right there in front of you, you might decide to paint a wonderful mountain range you may have only glimpsed out of the car window on your last vacation; or your favourite National Park as you think it might look in a storm; or, better still, somewhere you've never been in your life, somewhere so isolated and beautiful that no-one has ever seen it! You can make it up . . . because that's what your imagination is capable of helping you to do.

After this you'll be better equipped to absorb, record, recall and use your impressions for watercolors painted long after you visited your locations. Other artists have been doing this for centuries, among them the great English watercolorist J.M.W. Turner who, using memory and notes, could paint locations

he hadn't visited for 30 years or more!

No doubt you already use your imagination freely whenever you read a book, go to the movies, dream, or even plan for the future with your family. It's a wonderful talent we were all born with. Learning how to make the best use of it in your art makes good sense. You may be surprised how powerful an artistic tool your imagination is — especially if, like so many watercolorists, you've been limiting yourself to painting only what is in front of you.

In this book I have also included a comprehensive section on idea starters. I'll show you how to use your photo collection to create original paintings (not just copies of your photos); and I'll show you how to start with no ideas at all, developing as you go along, until you create a realistic landscape.

I hope that you'll find many ideas here that you can develop in your own way. After all, the main goal is to be your own artist, enjoying your painting experiences and discovering a little more about yourself and watercolor every time you paint.

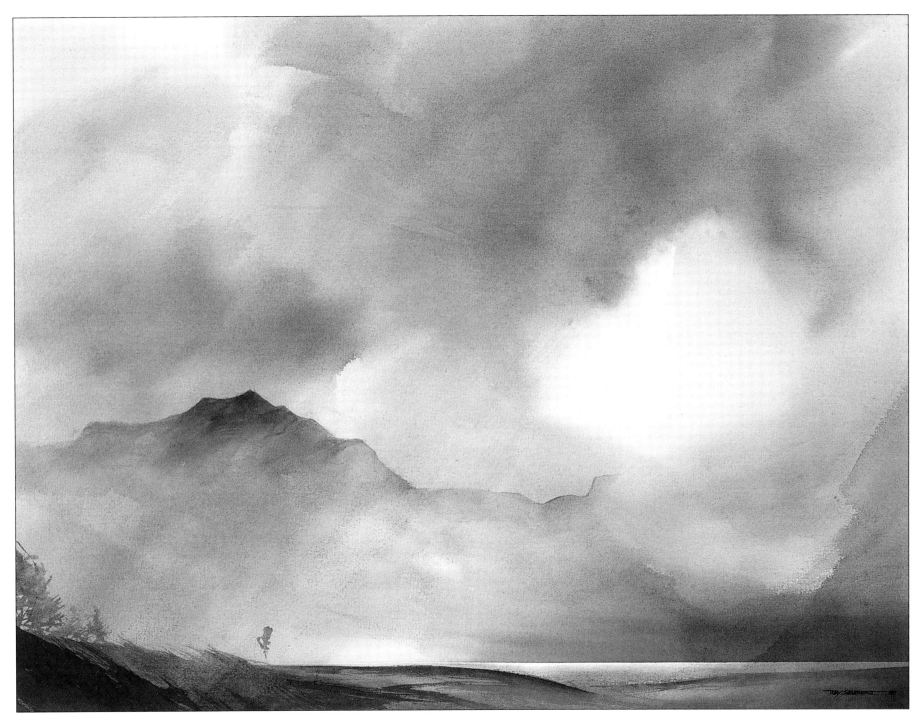

"Tasmanian Lakeland" Watercolor 21.3 x 29.1" (540mm x 740 mm)

PART I: GETTING THE MOST FROM THE MEDIUM

PAINTING FROM YOUR IMAGINATION

Creative watercolor, what is it?

Develop your creativity while you paint by:

- Thinking creatively.
- Being creative.
- Stimulating your creativity.
- Using sketches and note taking to absorb ideas.
- Using your notes creatively.

How to use the "Understand It" approach to landscape and watercolor.

The anatomy of an imaginary landscape.

THE NATURE OF WATERCOLOR

Learn how watercolor works and how you can use this knowledge to improve your painting.

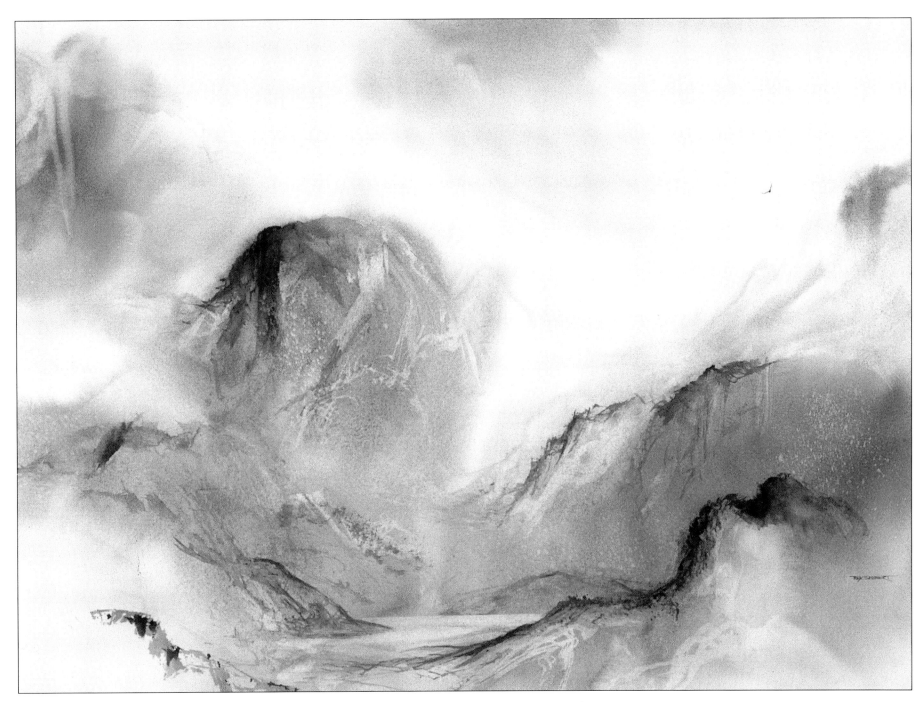

"The Void" Watercolor 23.6 x 30.7" (600mm x 780mm)

CHAPTER 1: PAINTING FROM YOUR IMAGINATION

Creative watercolor, what is it?

Give watercolor a chance and it will do some of the creating for you! A whole world of possibilities will unfold once you discover how watercolor actually works and then all that is required is to keep your eyes open to the possibilities that present themselves while you are actually painting. If you do this, I'm sure you will conclude that the process of painting is as important in creating original art as, say, your preliminary sketches and color notes. Along the way you may also discover a level of creativity within yourself that you never knew existed.

Ask any watercolorist and I'm sure they'll tell you that every painting has the potential to be an adventure into the unexpected. Some people welcome this, while others believe that an artist should maintain complete control throughout the painting process.

Here's how I see it: when something unplanned happens to a wash, or a pigment reacts in a way which is new to me, I have the opportunity to incorporate this "accident" into the painting. Occasionally, I lose a painting to disaster but, more often, the unexpected simply changes my direction.

A good example is the process of painting skies using the "wet-in-wet" technique. The best part of wet-in-wet is that the clouds seem to form themselves (because of the natural inclination of the wash to explode into cloud-like shapes when it is introduced to a wetted sheet). Although you can never be completely sure how the paint will behave because of the many factors involved, you will eventually have a pretty fair idea of what to expect. By coaxing the washes into "a

windy day", or "a storm", say, you can collaborate with the watercolor so that together you can create a sky which looks real, even though it's not painted from real life.

Some people paint *using* watercolor: others paint *with* it. An artist who merely uses watercolor to paint landscape, and who does not see it as a companion in the endeavour, will seldom coax from it the eloquence of which it is capable, and may never see its true potential as a creative medium. I firmly believe that it is important to understand the nature of watercolor — the way that it works — and to adapt your painting methods so that you work in harmony with it.

Creativity
Lots of people believe you have to be "born creative". How often have you heard, "Oh, I don't have any talent, I wasn't born creative"?

"Creative" people are supposed to be able to pick up a brush and produce something "original" almost at whim. In fact, creativity in watercolor is far more likely to manifest itself once you know more about the medium — and about Nature.

The experience of painting is a great teacher and so I encourage you to experiment with all the activities outlined in this book. I hope you'll find that your increased self-confidence in the medium — once you have seen how easy it is to create original landscapes — is a wonderful stimulus to your creativity.

Creativity in watercolor does not limit itself to having a good idea before you start. In fact, you may start a picture with

no idea at all of what you want to paint. The flow of water onto the page, or explosion of pigments, may be the sole stimulus that helps you to discover a world within the wash. Later on in this book, we'll look at how you can turn your discoveries into finished paintings.

Thinking creatively
There's a big difference between being someone who wants to paint creatively and someone who can actually do so. The first step is to *think* creatively.

An average painter, faced with a scene, might be content to sit down and portray it as it is. But once you decide you are going to create original landscapes, you can move things around! Why not? Who's going to stop you?

For a start, that tree might look better on the left not the right. Or perhaps a group of them might look more interesting with a few more smaller trees in the background to balance the composition? What about a storm coming in from the right? Or a range of mountains beyond the fields — mountains caught by the last rays of the sun? The possibilities are endless once you give yourself permission to start. All it takes is a little imagination and the conscious effort to think creatively.

Being creative
After a while, creative thinking becomes habit-forming. It just happens. Landscape (in fact any art subject) stops being something fixed, which you are obliged to paint "as-is". Landscape is not a thing; it's a possibility! Your

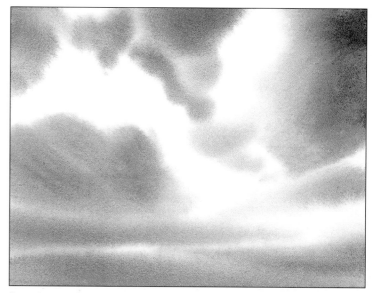
A wet-in-wet sky.

landscapes don't even have to look real, you can make them as fanciful as you like.

In this book we'll focus on landscapes you can believe in, but don't let that limit your imagination. I want you to *be* creative, not just *think* creatively. That is the first step. We're going to explore ways to consider your subject, medium, work-in-progress and even yourself, creatively.

Stimulating your creativity
Achievement is a great stimulus! But if you are about to take your first steps into creative freedom, I think I should warn you: once you fire up your imagination you'll have to feed it! And success will make it hungry! If you're like me, then when that first original landscape emerges from the wash, your life may change! I still remember the

time and place I painted my first true "original". And how I felt! I was up late and remember waking my wife, who is also an artist, and although I said something dumb to her like, "Look! I'm a Watercolorist!", it was the beginning of my new career.

The importance of note taking and sketchbooks
Later I'll show you how to kick-start your imagination in unusual ways, and demonstrate why it is so important to maintain a sketchbook of ideas and notes. Notes are a critical part of learning to see like an artist and they'll help you to analyze and absorb the world around you. They are an essential part of transforming your real life observations into imaginary landscapes later on. Along the way notes will help you

to develop and sustain your visual awareness and provide you with a ready source of visual reference material.

Using your notes creatively
A glance at almost any creative artist's notes and sketchbooks reveals how important these are. Notes and preliminary sketches, from all angles, evolve into composite sketches that can be followed by imaginative studies in which the only rule is: explore the possibilities! Often, if you trace the subject far enough, you may find that the artist has created an artwork which bears little or no resemblance to the original source material from which it was developed. This is an example of the *creative process*. You can train yourself to use the same process which, if you haven't done it before, will transform your thinking.

How to use the "Understand It" approach to watercolor
Some people think that watercolor is a difficult medium. It isn't but, like most things, only becomes easy once you know how. The trick lies in learning how to learn it. Experience is, of course, the best teacher of all, which means that you will understand how to use it when you have become familiar with how the medium performs under various conditions. Let's call this the "Understand It" approach to watercolor.

You can also accelerate the learning process. You can learn from teachers, fellow painters, books, videos, seminars and so on. But you won't really understand the medium until you can use it. Hence, the key to understanding is practice, practice, practice.

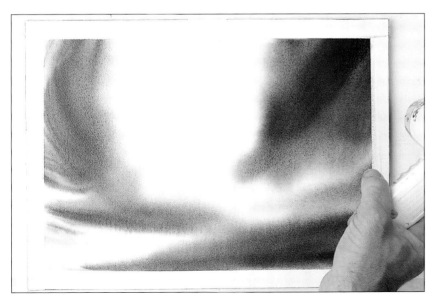

Within moments an empty sheet becomes a dramatic environment . . .

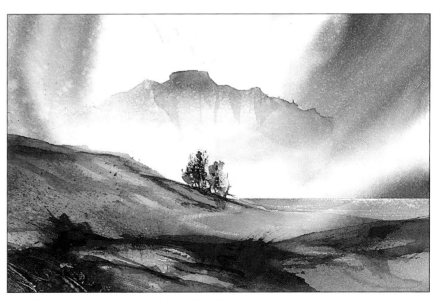

. . . within which you discover a fully realized landscape.

Anatomy of an imaginary landscape

Gradated wash for the sky and hills.

Wide brush for the shadows.

Wet-in-wet for the trees.

Dry-brush for the grass.

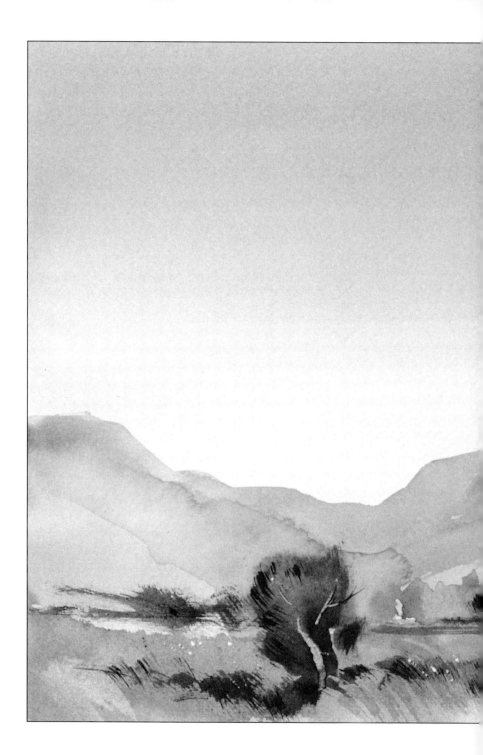

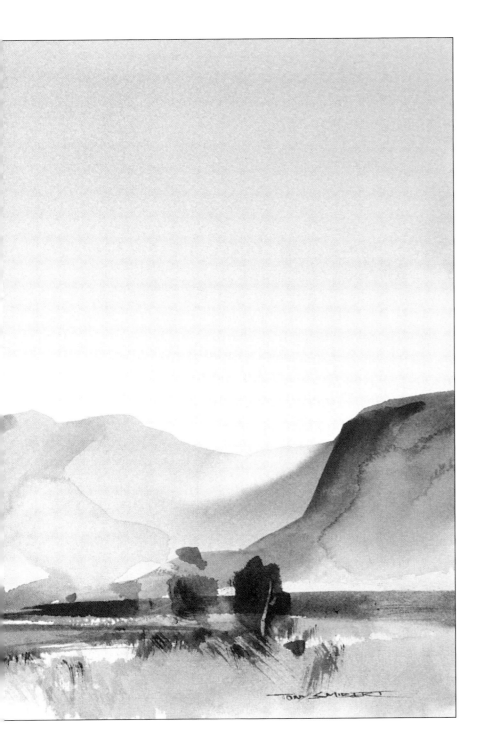

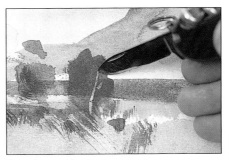

Scraping-out for the tree trunks.

Fine brushwork for the details.

Spatter for the rocks and grass.

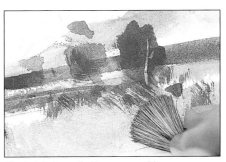

Final details unify the composition.

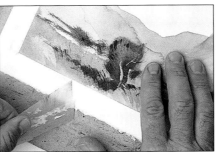

To finish, remove the tape.

CHAPTER 2: THE NATURE OF WATERCOLOR

There's no great mystery to watercolor

Watercolor is Nature at work. A wash works very much like sediment settling in a pond. Over time, finely ground dust carried in by water, settles by its own weight onto a "submerged" surface of paper. After the water has evaporated, the layer of colored dust is left clinging to the paper — where it dries out, cures, and awaits another flooding of the surface and further layers of colored sediment. Second and third layers will seldom disturb the first if it's not stirred up by the artist during these successive floodings.

Using the pond analogy, it stands to reason that if a child waded through in rubber boots during the delicate settling process this would disturb the fragile layers. Yet in summer, the same child, running about on the surface of the dried-out pond bed, might hardly disturb the layers at all.

Watercolor painters benefit from knowing the natural processes at work in their medium. The essence of painting in watercolor is to understand and work with the simple mysteries of SUSPENSION, SETTLING and DRYING which take place every time we lay a wash. If you allow things to happen in their own way, and tune-in to the natural harmonies of it all, then you may also discover the many creative opportunities that arise every time this process takes place on the surface of your painting.

Now let's imagine that same layer of colored dust carried, not by water, but by wind. Imagine throwing a handful of finely ground blue dust into the air wherever you are now. It would settle on things all around you which would now appear to be "bluer" than they were! And you would still expect to see the original colors of your surroundings through this fine dusting of blue. The red on your sweater would still be red (but bluer), the flower pattern on the lounge chair would still show all its colors, but each color would be seen through this even dusting of blue, and so on. It would take an enormous amount of dust to completely obliterate the actual colors of the objects around you. This is pretty much what happens when you lay a colored wash of

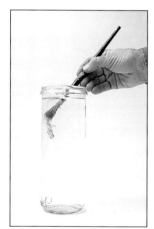 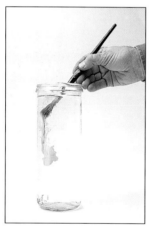 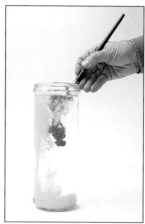 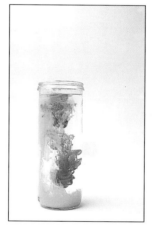 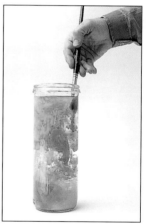 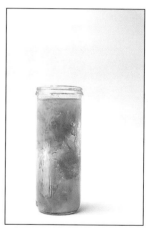

The best way to tune in to watercolor is to observe how it works for yourself. Fill a large jar with water. Introduce a brush loaded with yellow wash to the still water *without stirring* and the pigment immediately starts to loosen its hold on the brush.

It "takes a dive" and tumbles towards the bottom of the jar, where it will in time settle into a cloud and then, finally, as a layer of colored dust.

But, before it's allowed to settle, introduce another brushload of pigment. Red this time.

The pigments swirl and dance together, caught up in the movement of the water, which has been slightly disturbed by the comings and goings.

Next, add blue.

Again the colors retain their integrity. There is a natural and harmonious beauty in the way the colors interact, for each color has retained its essential brilliance — although the quantity of pigment has lessened the amount of light passing through the water and reflecting back to us from the white background beyond.

Let's observe how watercolors appear on white and black paper. One of these brushstrokes carried transparent watercolor, the other carried watercolor plus white (gouache). The transparent watercolor has virtually disappeared on the black paper, yet opaque watercolor is equally visible on both sheets. This appears to be an advantage at first glance. But, if you use gouache, you deny yourself many of the creative options which are at your disposal using transparent wash. Many artists ban gouache from their paintbox altogether. I use it whenever I want to, but I now realize the consequences and so I'm very careful not to accidentally mix it with my other washes as a result of residue in either my brush or my water-jar. You'll have to make up your own mind about whether to allow opaque wash into your palette. After all: there are no rules in watercolor, only consequences.

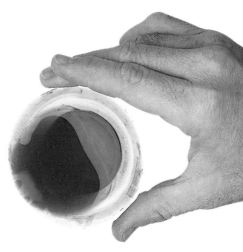

After a while the pigment will settle — even in a well prepared wash.

watercolor over dry areas which you have already laid down in other colors. You see one color *through* the other — which is basic to your understanding of what is meant by *transparency* in watercolor.

The best way to tune in to watercolor is to observe how it works for yourself.

Why not try my experiment using the jar of water for yourself?

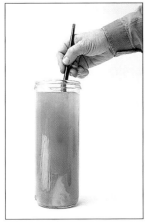

Now, this next point is important. Up until now you have allowed the watercolor to work in its own way. But, if you use the brush to clumsily stir up the water, causing all the colors to mix together, "the lights go out" and you will be left with a dull, muddy color. Add one color to another and the result is nearly always duller than either color on its own.

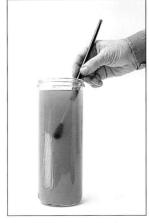

In transparent watercolor the lighter areas come from reflected light bouncing back off the white paper on which we work. This comes to us through the layers of wash. The more paint you apply, the less light comes through. In this case, the whites have disappeared entirely.

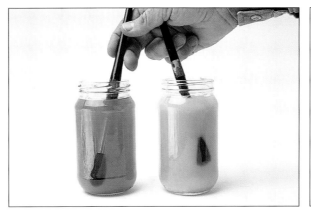

In these two jars you can see the difference between transparent watercolor and opaque watercolor (often called "bodycolor" or "gouache"). Both carry a very weak solution of Cadmium Red. I added a small amount of Chinese White to the jar on the right. Of course the red is now light BUT the solution is cloudy and its transparency has disappeared. You can't see the background at all, and the two brushes pressed up to the glass in front show you just how opaque this gouache is.

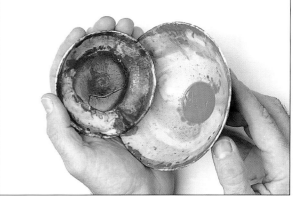

Study your medium. When the water evaporates from your dishes the pigments will dry out like mud in a clay pan. This is the nature of watercolor.

Occasionally pigment may even craze and crack, or break away in flakes as it has with this Indigo.

PART II: MASTERING THE MEDIUM

STUDIO AND MATERIALS

How to set up your studio space:
- Paint.
- Furniture.
- Brushes.
- Paper.

GETTING STARTED

How to prepare washes and mix secondary washes.

Discover the secret of "working small to make big discoveries".

How to make a watercolor workchart.

THE TRADITIONAL TECHNIQUES THAT MAKE IT ALL POSSIBLE

Understanding the basic washes:
- Flat.
- Gradated.
- Variegated.

Techniques you must know:
- Wet-in-wet.
- Dry-brush.
- Mingling.
- Charging.

Discover how these techniques can be used to create a landscape.

MAKING MARKS

Exercises in creative brushwork:
- Skies.
- Trees.
- Rocks.
- Grass.

Interesting marks with other equipment.

COMPOSITION

Composition is easy.

Traditional principles you can use.

How to lead the eye of your viewer.

Discover composition sketches in both pencil and pen-and-wash.

Building a landscape from the ground up.

Composition confidence: why you should have confidence in your own ideas about what looks "right".

COLOR CONFIDENCE

Learn how to paint small color notes first.

Color sketching for color confidence.

How to use limited palette sketches in low and high-key colors.

USING PHOTOGRAPHS CREATIVELY

Discover how you can use photos to create original paintings by:
- Combining elements from different photographs.
- Using photographs to add details to an imaginary landscape.
- Using the camera as a compositional tool.
- Building up your own photo reference library.
- Sketching from photos using the three-line method.
- Painting color notes from photographs.

CREATIVE PHOTO REFERENCE LIBRARY

A collection of photographs of land, sea, sky and foliage for you to use in your work.

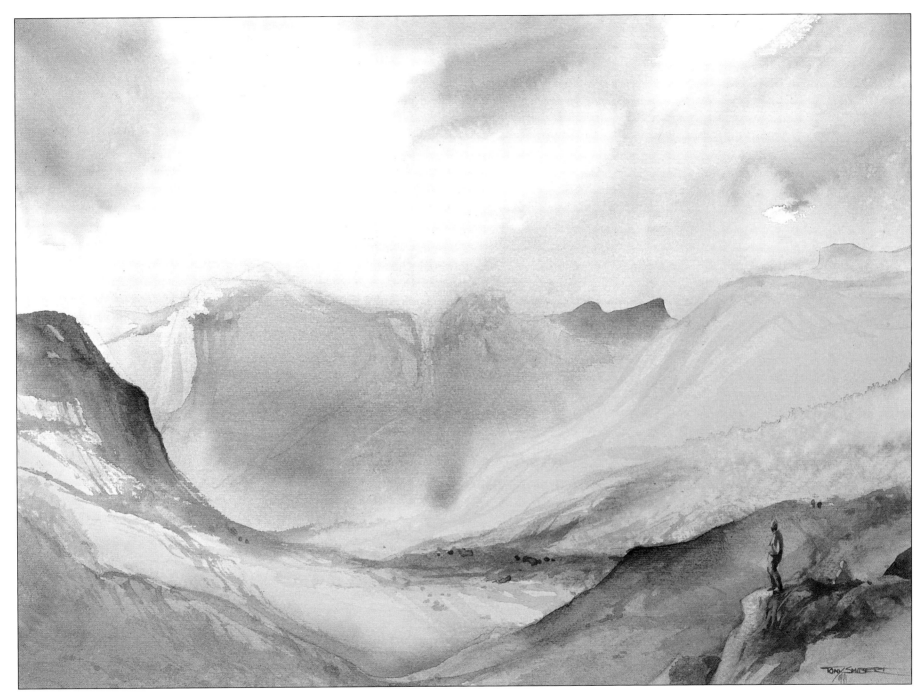

"Viewing the Citadel" Watercolor 10.2 x 14.1" (260mm x 360mm)

CHAPTER 3: STUDIO AND MATERIALS

A studio space to call your own

Every watercolorist needs somewhere to work. But don't worry if you haven't a "proper" studio — all you need is somewhere to set up when you're working, and somewhere to store things away when you're not. A studio is not only a place, it's a state of mind. Wherever you paint is your studio when you are working there.

In this chapter I'll tell you how I organized my working space — which may help you organize yours. As time goes by, your own particular requirements will become apparent. Your studio will have to evolve with you to meet your needs. If you do decide to set up a studio (or studio area), you'll need at least some of the following.

A table
The center of operations in my studio is a large table with a white, "splashable" surface. It's large enough to spread out all my gear; it's near a window, and there's a decent electric light above it. This table is important because I usually work "flat", rather than at an easel.

Window
In the northern hemisphere a large, north-facing window is ideal; in the southern hemisphere you'll need a south-facing window. If you have a choice, lay claim to a window with a pleasant outlook.

Lighting
I installed a special daylight-balanced fluorescent tube above my own table. As daylight fades, the transition to electric light is barely noticeable and I can work on into the night. A fluorescent tube also casts very few shadows, unlike a standard globe.

Chair
An adjustable chair on wheels is a wonderful asset to any artist's studio. Proper adjustment will help to ensure that you don't develop back or neck trouble from bad posture while you are working.

Sink or wash-trough
Nothing beats the luxury of a tap and a sink in the studio. You will need plenty of clean water and somewhere close-by to empty your jars. But if you haven't got them don't give up: lots of people make do with two buckets (one for clean water, one for dirty water) or a collection of plastic bottles. Improvize, it's no big deal!

Storage
Another obvious requirement is storage. Where will you keep your paper? In an expensive plan-press cabinet or a simple folio? And what about storage for paints, rags, tissues, palette-knives, and so on? Do you really need a cupboard; or will a plastic carry-crate do? Perhaps the most important question is: where will you

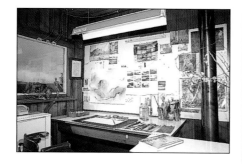

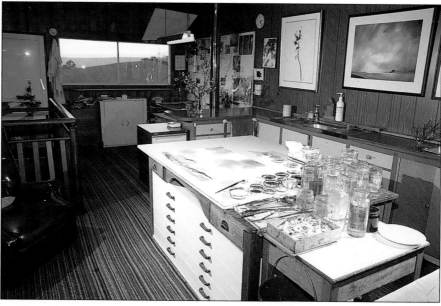

store your finished art? In my case it's under a second table, which rests on top of a plan cabinet. This is also the area where I work on larger paintings.

Display area
I like to surround myself with lots of interesting source material: prints, photos, artworks, sketches, color notes, color charts, color samples, cuttings — anything that may stimulate me when I'm working.

Consider having an area to display your finished work. At first, it may just be a pinboard with good lighting and a few mats; then later perhaps, a more elaborate set-up to help you display your work to other people. (Years ago my wife and I built our own gallery. It was an expensive investment, but has enabled us to support our family by the sale of my paintings and her screened prints.)

Setting out your gear
Here's how I usually set out my own gear. Because I'm right-handed, my water jars (a small one for rinsing brushes and at least a couple of large ones for clean water), and brushes (plenty of them), are to my right. Directly above are prepared washes and to the left my tissues and paints. I always set things up the same way, not because it's the best way, but because I have to know where everything is so that I can grab whatever I need at a moment's notice.

Other items.
As we go along I'll be showing you ways to use all sorts of items that will help you create original landscapes. On my table you'll often find plastic cling-wrap, razor blades, erasers of various sorts, a spray bottle, a metal ruler, my trusty hairdryer (not the one from the bathroom, they won't let me use that one!), pencils, pens, twigs, branches, lots of old toothbrushes, sketchbooks, photo albums, masking tape, removable "invisible" tape, my Swiss Army Knife and very often . . . a cup of tea!

Paint, brushes and paper
Paper, brush and paint are your traveling companions along what I like to call "the Watercolor Road". Choose them carefully.

In the last chapter I explained how important it is to understand the nature of watercolor before you begin. But right now I need to give some very clear advice: *be prepared to invest in the best paper, paint and brushes that you can afford.*

The best watercolor advice I ever received was: "You'll be better off with one piece of good quality paper, a couple of tubes of artist quality paint and a single good brush, than with a room full of poor quality materials!"

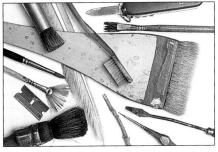

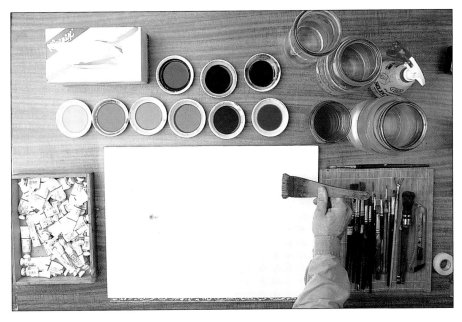

The cheap stuff usually doesn't perform very well, and is actually more difficult to learn to paint with! Therefore, it makes more sense to start with smaller quantities of the best you can afford, because the savings in time when you succeed from the very beginning make the financial investment worthwhile.

By buying carefully, you'll sidestep many of the problems encountered by first-time painters who start up with cheap equipment and paints, and find themselves struggling on and on — only because paper, paint or brush are not appropriate to the task.

Brushes

Sable brushes are still regarded by many artists as the best. However, they're very expensive and animals do suffer to give us the fine hairs on which these brushes depend. On the brighter side, synthetic hair brushes are catching up fast.

You will need a range of brushes. I suggest two good quality round sables, or substitute, size #00 or #01, and #10 or #12, and two good quality flat wash brushes in nylon or something similar. You should also buy a good hake wash brush and a hog hair fan. My fan brush, as you'll see, is pretty old and ragged now, but I'm used to it. You'll see it and other brushes in use in the demonstrations.

There is one other specialty brush often left off the "essential" list for watercolor. It's a mixing brush (or two). That expensive sable is not designed to be a mixer! Any old hog hair or similar will do. A cheap oil brush is fine, but don't introduce one that you've already used for oils into your watercolor area!

Your art supplier

Your best friend in all this should be your art materials supplier. It's worth trying to establish a good working relationship.

Let your retailer know that you are serious about watercolor. They will see you as a good investment and most retailers will go out of their way to help you spend wisely because they want you to come back to them for more!

But don't expect them to be experts in watercolor. You do have to know your own craft. Most retailers can give good advice on the reputation of various materials and are able to help you identify quality, but your best long term guide to the uses of each item will be your experience.

Your choice of materials should always reflect an understanding of the practical use you intend for them. Starting out, you won't have the understanding, but you can expect it to develop. Be your own scientist. Observe and analyze, as you go along, and understanding will come to you very quickly — along with confidence.

Buying paper

You must have reliable paper, so start off by buying the better known brands. Purchase cotton or rag-based paper labelled "for watercolor". Paper should be acid-free (neutral pH), and unbleached.

Sizing

Watercolor paper is commonly sized with a weak glue to affect absorbency. Without sizing, most papers would absorb like blotting paper! With time you'll learn to recognize and work with the sizing of different papers. This is part of the "inner art" of watercolor, your intuitive relationship with the medium, which can only be acquired through the exercise of painting itself.

I find some papers are a joy to work with, while others don't suit me or my work. We're all different, and so while you choose one paper, expect to find your

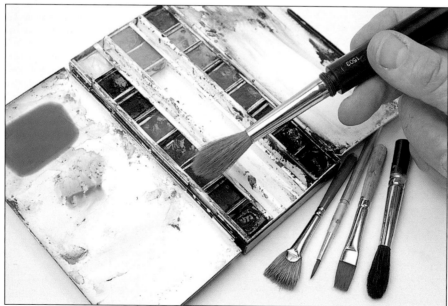

friends choosing another. It's worth noting that certain papers are ideally suited to certain tasks, while others perform over a wide range of processes.

Rough, medium and smooth
Paper usually comes in "rough", "medium" and "smooth" surfaces. This affects the performance of pigment as it settles. Laid flat, and viewed through a magnifying glass, the surface of rough paper is a vast plain comprising high and low areas. Depending on the "tooth", as it's known, these hills and valleys are more or less extreme. Now, imagine introducing a wash of watercolor to this plain. Like a flood, it inundates the surface of the paper; soaking in somewhat, settling deepest in the low areas and fairly quickly evaporating from the highest points (the tops of the bumps). But before this happens the pigment (which, you remember, is suspended

in the water) settles itself like silt in the hollows. Consequently, a wash applied to a rough surface leads to an uneven settling of pigment, visible and often delightful to the naked eye. It stands to reason that a similar wash applied to medium or smooth papers will produce completely different results. With dry-brush work, this rough surface acts in a different way, often catching the pigment only at the tops of the bumps and leaving the low points of the paper unpainted. Despite its delights, I seldom use rough paper myself, and suggest that medium will best suit most of the exercises in this book.

Hot pressed, cold pressed, not pressed
Just a bit more about paper. Don't be confused by "hot pressed" (HP), "cold pressed" (CP) and "not pressed" (NP). Put simply: the surface of hot pressed paper has been flattened and smoothed to create an effect on the surface of the

paper, similar to the effect a hot iron has on clothes! The result, for the painter, is that the surface is less receptive to watercolor (which tends to stay on the surface) and can consequently be corrected and wiped back to a fairly clean surface (a boon to designers and illustrators).

The demonstrations in this book were all painted on medium surface, cold (or not pressed), paper.

What about weight?
When you start out it's tempting to buy lighter papers because they're less expensive, but, lighter papers pose more technical problems for a beginner. If you buy a sheet of very light paper, (say, 185 gsm), you will first of all have to stretch it. This is not difficult, but it is time-consuming, and it distracts you from doing what you really want to do, which is to START PAINTING, now, today! Also, a light weight sheet won't

Understanding GSM

On the subject of grammes per square meter (gsm) versus pounds per ream as a way of describing paper weight I'm grateful to Blue Lake Handmade Papers for the following advice: "Quoting the weight of a sheet in gsm is now worldwide and is much easier to understand than pounds per ream which gives a different number for each size of sheet."

For that very good reason I'm only using gsm in this book. I hope this will help you if you want to select equivalent weights to those I've used. Should you encounter commercially available papers which do not give their weight in gsm, but only in pounds per ream, I suggest asking your art supplier to advise you as to the gsm equivalent. Most art suppliers are only too happy to help you choose the right materials.

hold as much water, and can't be worked as hard (because it becomes fragile and prone to tear when wet). Finally, (because paper fibers expand when soaked) light weight sheets are always the first to "cockle" (becoming loose and buckling up while you're working on them). This is not what a beginner needs!

Paint

When I paint or sketch out of doors, I rely on my box of semi-moist pans. The demonstrations in this book, however, were mostly painted in the studio with washes mixed in dishes from tubes of artist quality paints.

"Artist quality" paint is generally better in every way than colors labelled "Student quality". If you can afford it, buy artist quality from the beginning. Otherwise buy student quality of a reputable brand. With the well-established brands, quality should be assured.

Among the pigments you will see me using are: Payne's Gray, Yellow Ochre, Cobalt Blue, Light Red, Indigo, French Ultramarine Blue, Phthalo Blue, Raw Umber, Cadmium Orange, Cerulean Blue, Cadmium Red, Hooker's Green Dark, Alizarin Crimson, Lamp Black, and Chinese White.

You'll see them clearly identified throughout the book.

Palettes

Most of my career I've been looking for the perfect mixing surface. Although I have a box full of used and abandoned plastic palettes of exotic design, I now favor plain white porcelain Chinese sauce dishes for most of my work. They're inexpensive, don't stain, and feel good (with a tactile quality that my plastic palettes lack). And, when you spill one of them, you only spill the one (unlike a palette made up of lots of connected dishes).

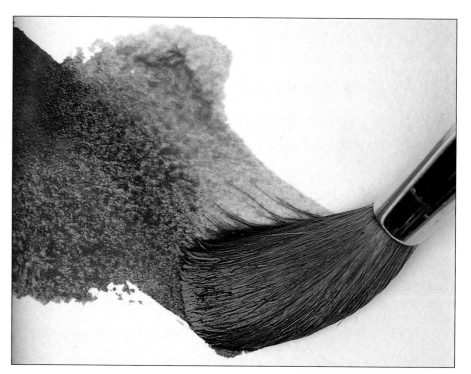

COBALT BLUE

PHTHALO BLUE
(OR WINSOR BLUE)

FRENCH
ULTRAMARINE BLUE

CERULEAN BLUE

INDIGO

HOOKER'S GREEN DARK
(OR WINSOR GREEN)

PAYNE'S GRAY

ALIZARIN CRIMSON

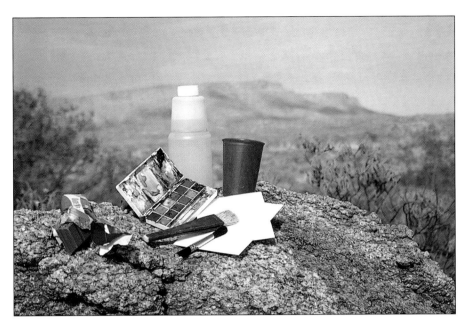

BUT, IN THE FIELD, SUFFICIENT IS ENOUGH!

Out of your pockets and onto the ground: a small sketcher's kit of pans, a cut-down brush or two, pencil, tissues and pieces of your favorite heavy weight paper (640 gsm this time) cut down to size, water in a children's plastic drink-bottle and cup combination. Later I'll show an even more minimum set up. The chocolate? I wouldn't go painting without it!

That's enough about equipment at this stage. Let's get started!

LAMP BLACK

LIGHT RED

YELLOW OCHRE

CADMIUM ORANGE

RAW UMBER

CADMIUM RED

CHAPTER 4: GETTING STARTED

You've got your gear and can't wait to start

In this chapter I'll show you how to prepare washes prior to painting and how to mix secondary washes by combining colors.

I'm also going to explain why it's clever to start out by working on little paintings at first, and doing lots of them, then I'll show you how to create a watercolor workchart.

But first, let's mix some paint!

PREPARING A WASH

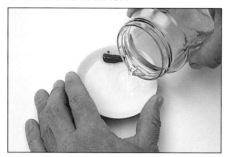

Using a saucer as a palette (mine are inexpensive white ceramic Chinese dishes from a discount store), squeeze out a generous dollop of paint on the upper edge of the dish. (About the same amount as you would when squeezing out toothpaste.) Add water to the dish. Not too much, you can always add more. . .

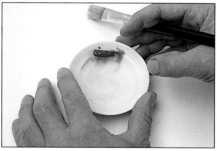

Notice that the paint and water are eager to mix. Exciting isn't it!

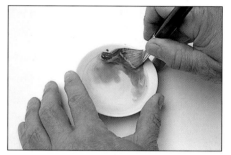

Using a bristle brush as a mixer (don't rough-up your good sable for this process), smear the paint out from the edge of the dollop and work it around in the dish.

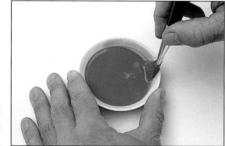

Take a little more paint each time until it's all mixed. Be careful not to leave submerged lumps which will spoil your wash.

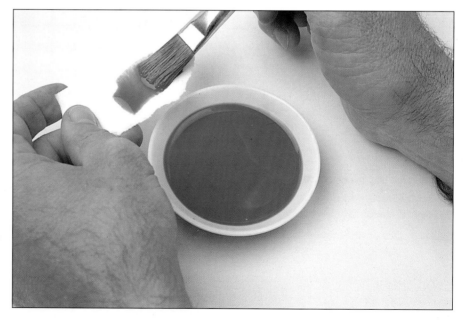

Test the resulting color for evenness of mixing, and for strength, by testing it on a scrap of paper. And remember: colors dry lighter. A dark color when wet may prove disappointingly pale after it dries on your painting.

PREPARING A SECONDARY WASH

Now we're going to mix up a color which does not come straight from the tube. There are lots of ways to do this, but I'm going to show you one which has always worked well for me.

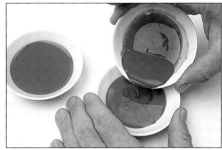

Let's mix a rather beautiful gray by combining Light Red and Cobalt Blue. Unless the quantities are managed, Light Red will overwhelm Cobalt Blue; and so the skill lies in starting with a quantity of wash in the weaker color and then adding to it small quantities of the stronger color. (It's a little like adding salt to potatoes — rather than the other way around!) You'll need two dishes of pre-mixed wash in those two colors and an empty, third dish for the gray. Oh, and your mixing brush, of course.

Pour a quantity of Cobalt Blue into the clean saucer.

Pour in a small quantity of Light Red. (You can always add more if it's not right).

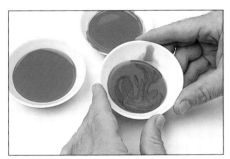

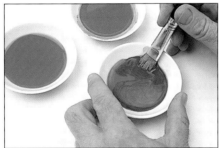

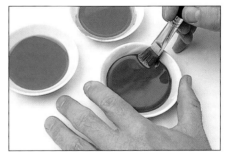

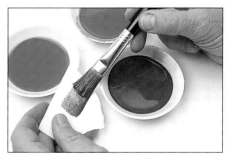

Part of the pleasure of this task lies in enjoying the way the colors intermingle.

Mix them well.

Make sure that the secondary wash is completely mixed.

Test the color. If it lacks one or other pigment, add more. Depending on what you intend to use it for this gray can be mixed to give you a range of colors applicable to all sorts of uses. As mixed here — a neutral gray — it is very good for painting clouds or shadowed mountains.

Exercise sheets

An exercise sheet is a piece of paper you use when you are practising a skill or testing out an effect, or even making color notes or studies prior to commencing a major work. Lots of exercises turn out quite well, so don't be surprised if you find yourself framing a few! I keep a supply of exercise sheets cut (16 to a page) from larger, full sheets of heavy weight watercolor paper. I prefer to work small at first and thoroughly recommend it to anyone who wants to acquire watercolor technique FAST. The trick is to do lots of these exercises.

With medium to heavy weight paper you can work on both sides (there's no show-through), so a single full-sized sheet will provide you with 32 surfaces, and you can tape the picture straight down onto a light weight board without the need for stretching. This saves you time, allowing you to move quickly from one sheet to another while you are teaching yourself the basic techniques. Those big paintings can come later!

Work small — learn big!

If you're a beginner and you paint on big sheets, with small brushes and very little paint, you are making life very difficult for yourself. You'll probably find the going much easier if you confine yourself to smaller paintings, using a larger brush and stronger washes.

Why? The reason is, you can see the whole thing very easily if it's small. This assists you to make decisions about composition, because you are far more aware of the impact of each mark you make — regardless of where it goes in the composition.

Each picture, large or small, is a fresh learning experience. Therefore, the more pictures you paint, the more opportunities there are to learn. And you can paint lots of small exercises, studies or finished works in the time you might spend on one large *tour de force*.

On a budget level, you'll find it very economical to buy heavy weight, high quality paper and then to cut it up or mask it into smaller painting areas. As I have said, you can create 32 or more smaller painting areas out of a single full-sheet!

Much of my own exhibition work is very large now, but I still create most studies and many finished works on quite small sheets. It's great fun, and I can't wait to get on to the next one — I occasionally finish ten or more detailed paintings in a day.

Big paintings are harder to manage. They usually require bigger brushes, more brushstrokes and the mixing and handling of vastly more paint (more expense) while all the time you are struggling to maintain your compositional overview. The beginner often finds that larger paintings are a real problem — rather than a joy to complete.

What else can you do? Use a bigger brush on that small sheet! You'll start to achieve decisive results, with major compositional impact, very easily. You'll have to be bold. You'll make big mistakes, but you'll also have big successes. A big art work is not necessarily a better art work. The "Mona Lisa" is not a large painting yet it rates in significance with the Sistine Chapel.

Here's my maxim: A small sheet, plus a large brush, plus richer washes will give you a better start than a larger sheet with a smaller brush and weaker washes. Along the way you'll learn plenty about brush control, composition, boldness, restraint and all the rest of it. What you learned "small" will easily translate into "big" when you feel the urge to produce something larger.

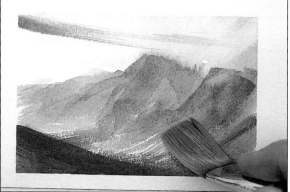
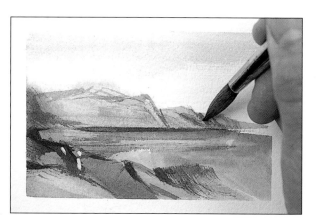

How to make a watercolor workchart

Divide a sheet of watercolor paper into smaller painting areas by laying down a "grid" of masking tape or some other appropriate tape. Check that your tape and paper are compatible, providing reliable masking of the borders around each little painting area and removal without tearing. Some of the softer papers cannot handle this and so your only option may be to use "removable" tape.

I mostly use a high quality see-through tape because I like to measure the intensity of my washes against the white of the paper while painting (although here I used masking tape so that you could see the demonstration clearly).

Tape your paper to a board. (I'm working on a gummed watercolor block but, because I still want to have a white border around the outer edge when I peel the tape off I tape it anyway.) Now the border will run all the way around the sheet.

Next, divide the sheet with vertical strips of tape. Start in the middle.

My top four hints

If I were allowed to give only four pieces of advice about watercolor for the beginner they would be:

1. Buy good materials from the start.

2. Take a few structured lessons from someone who can actually paint.

3. Do lots and lots of pictures.

4. Work in rich washes with a big brush on small paper.

Now place more strips on either side and the sheet will be divided into four. Then section the paper horizontally.

The result will be 16 separate painting areas. Smooth the tape down all around.

Notes

- Always wash your hands before handling paper because the natural oils from your skin can ruin paper for watercolor.

- Don't worry if the tapes are not positioned perfectly. Leave them, because peeling them up and moving them around to get them just right will usually disturb the surface of the paper. These areas may later appear as "marks" when you paint over them.

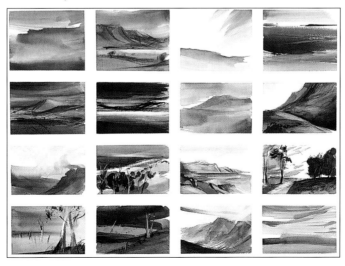

I've made scores of charts like this — every one of them different. I always encourage students to develop their own versions.

27

CHAPTER 5: THE TRADITIONAL TECHNIQUES THAT MAKE IT ALL POSSIBLE

Only eight basic processes can produce beautiful paintings

If you've never painted in watercolor before, this chapter will introduce you to the basic skills.

Once you know how to mix paint you're ready to put it to use! If you start with basic washes first, I think you'll find the more complex washes a breeze. We'll start with FLAT, GRADATED (gradated washes are sometimes called "graduated" or "graded" washes) and VARIEGATED washes, then you'll learn to use the techniques of DRY-BRUSH, WET-IN-WET, CHARGING, MINGLING and GRANULATION. Finally, I'll show you how to combine all of these processes into a few simple, yet beautiful, traditional landscapes.

To make the most of this part of the book I suggest you study the illustrations and accompanying descriptions of each process very carefully to absorb what's going on; then try out each exercise for yourself before reconsidering the demonstration and analyzing your results.

Don't worry if your paintings don't look exactly the same as mine. That's not the idea at all. Expect surprises — good and bad — and let yourself become excited by the possibilities inherent in the medium. You *will* develop a *feel* for watercolor; and when that happens you're half way to complete success, and will be creating your own original landscapes in watercolor for many years to come!

PROBLEM SOLVING

Most problems are not all that hard to solve. For example, many people find that their first attempts at flat and gradated washes result in thick, unnatural bands of color.

Don't let such problems put you off. Once you discover the knack of laying these washes the process is yours forever!

Experiment, remembering that the following factors will affect the result you get :

- The angle at which you incline the painting board.
- The thickness of the paint mix.
- The amount of clear water you pick up in your brush (for gradated washes).
- Whether you tend to "stop-start" all the time during the laying down of the wash.

Each wash, like everything else in watercolor, is a wonderful journey of discovery. I never know exactly what's going to happen! This experimentation stage can be great fun. Try your flat and gradated washes, again and again, on small areas of paper until you unlock their secrets.

Each exercise gives you the opportunity to learn by:

1. Studying the demonstration.
2. Copying the processes involved.
3. Experimenting.
4. Analyzing your results yourself. The idea is to practice until the skills involved become second nature and you can apply them whenever you want.

Please experiment with the exercises. Be your own painter and adapt what you want to your own work — the last thing I want is for you to paint just like me!

You should always feel free to do whatever you want in watercolor. There are no "exams" or test papers in this course, because, I repeat, in watercolor there are no rules; only consequences.

Seeing the inherent possibilities within simple processes is the first part of the creative genesis of original work.

FLAT WASH

Let's lay the most basic wash. Called a FLAT wash it was at the heart of watercolor for centuries. The idea of this exercise is to cover your painting surface with an even or "flat" layer of color.

A workchart is perfect for this and the other exercises I'll be showing you but, to make the demonstration easier to see, I'm going to use an exercise sheet of heavy weight paper taped to a prepared canvas board as a backing. I've run the tape all around and smoothed it down.

Take time to position your dish of wash where you can easily reach it (if you're right-handed put it to your right), load your brush and pass it from edge to edge across the top of the paper. Notice that I've angled the board so that the wash pools at the bottom of the stroke (gravity again!) and that each stroke travels just off the edge of the page and onto the tape.

Load again and pass the second stroke across just below and touching the first.

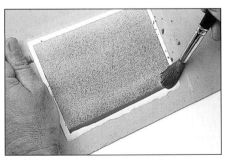

Notice that the wash rushes down to create an even curtain of color which descends with each successive pass of the brush until you reach the bottom.

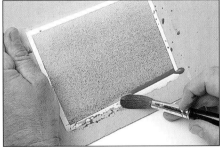

Squeeze out your brush to make it "thirsty". Use it to pick up the pool at the bottom of the page before laying the board flat to dry.

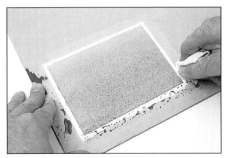

Wipe around the edges with a tissue. Otherwise you may find that color bleeds back into the drying wash from on top of the tape. This can ruin a wash!

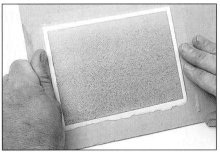

That's it, you've painted a flat wash — turning a white sheet into a blue sheet with a relatively even, or flat, glazing of color. At this point I often use a hairdryer to hasten the drying process, moving it back and forth across the work to ensure even drying.

SUCCESSIVE GLAZES

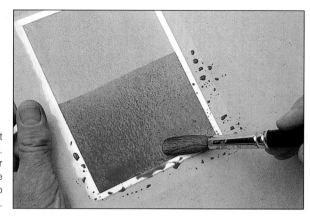

Here's what happens when successive layers of transparent watercolor are laid down. The process is called GLAZING. When your flat wash is completely dry turn the paper sideways and lay another flat wash over the lower half of the sheet. This lower area is now darker because it has two layers of blue over it.

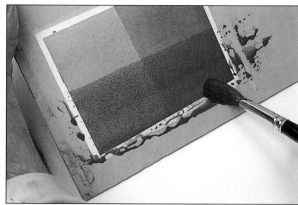

Now turn the board right-way-up again and repeat the process in what is now the lower half of the sheet.

The lower right corner (numbered 3) has three layers of blue and is darkest of all. The corners with only two layers of blue (both numbered 2) now read as a mid-tone, while the upper left corner with the original layer of wash now appears quite light. Notice that you can still see where the glazes have crossed. The ability to see one layer through another is what transparent watercolor is all about.

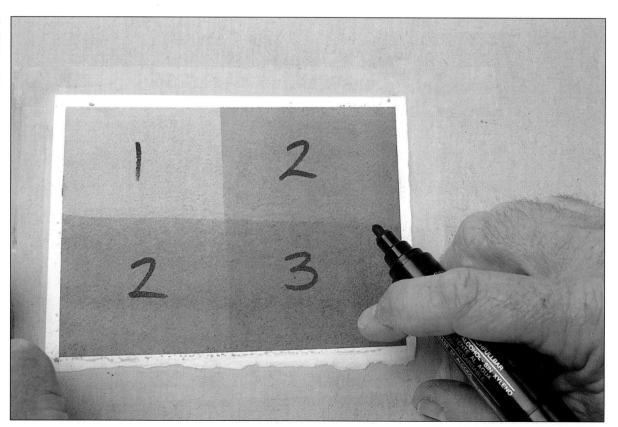

GRADATED WASH

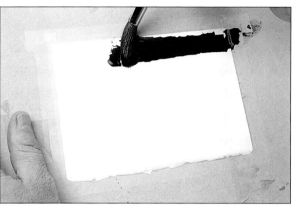

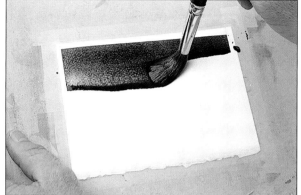

This wash is variously called "gradated", "graduated" or "graded". I flipped a coin and I'm going to call it GRADATED. It follows the flat wash very easily. Use Payne's Gray and have a large jar of water ready which you'll need to position nearby for this wash.

Start as for a flat wash but have plenty of water at hand to load up your brush. This time the wash will get lighter as it flows down the page because each successive stroke carries less pigment.

How? Easy! After the first stroke of full wash, load your brush with clear water. Do not rinse it out first, just dip it into the water jar before making the stroke. But note: there is skill involved in picking up just the right amount of water.

Collect more water with each stroke, while making a succession of passes just as you did with the flat wash, and there it is. You may have to change the angle of the board; lessening it with each stroke. With less paint, the strokes become runnier and so, to ensure an even pull towards the bottom, it may be necessary to change the angle.

Gradated washes require practice. Don't expect success first time (or every time). Go with the flow and you will pick it up! One hint: if you pause between strokes you may get a hard line between the passes because the first stroke has soaked in or even partly dried. Keep things moving along and you should have no trouble.

VARIEGATED WASH

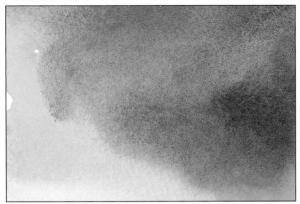

This is a beautiful wash. Notice how all the colors run together as if they have been painted by a rainbow brush. BECAUSE THE WASH CHANGES COLOR AS IT FLOWS ACROSS THE PAGE! If you're not in love with watercolor yet, you may be soon!

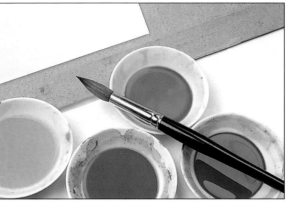

Prepare some dishes of Yellow Ochre, Cobalt Blue, Light Red and gray (made by adding Light Red to Cobalt Blue).

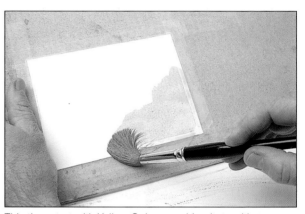

This time start with Yellow Ochre, washing it on with an informal brushstroke.

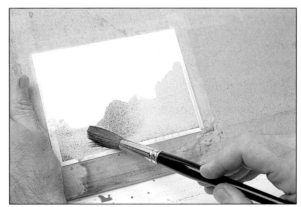

Next come successive strokes of Cobalt Blue, Light Red, and gray. Each new color begins where the last brushstroke finished so that the colors run together. Your finished wash

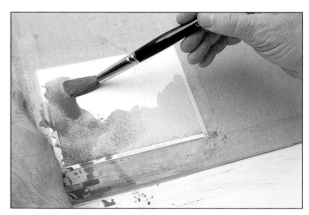

need not look exactly like mine. This wash allows you the flexibility to take in almost any direction you like. Use whatever colors you like too; the process is the same.

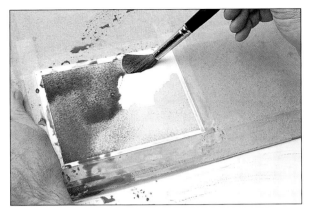

RESERVED WHITES

In the upper right corner of the exercise you'll see that I left an area of paper unpainted. This is called a RESERVED WHITE. (Just like a seat in a restaurant, it's reserved.)

DRY-BRUSH

Loading up my brush with blue, I made a couple of strokes directly onto the dry paper. This is known as working DRY-BRUSH and it's easy.

WET-IN-WET

If you do the same thing but this time wet the surface with clear water first, the blue will soften and blur. This is known as working WET-IN-WET.

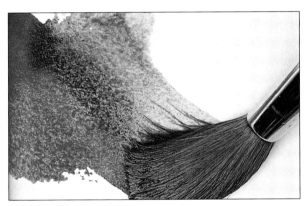

MINGLING

Lay any two dry-brush strokes next to each other and the edges will interact. With two colors the effect can be striking. This is called MINGLING.

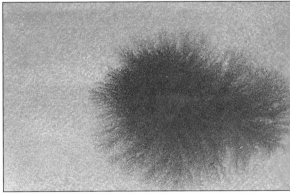

CHARGING

CHARGING watercolor has nothing to do with credit cards! This process involves dropping one color into another using wet-in-wet. When Cerulean Blue is charged with Cadmium Red, the effect is striking.

GRANULATION

Bring out that magnifying glass! In watercolor, GRANULATION refers to the way that some pigments suspended in a wash attract each other, massing together to create a texture which, when the wash settles and dries, remains on the surface to delight the eye.

Some colors granulate more than others, and they granulate in different ways.

You never be quite sure what will happen with granulation; the best you can do is to develop an awareness of the sorts of things that might happen! The resulting textural effects can be a great stimulus to the imagination.

For this exercise you'll need to premix small quantities of wash in each of the colors you decide to use. I used: Yellow Ochre, Ultramarine Blue, Payne's Gray, Cadmium Yellow, Lamp Black, Raw Umber, Cadmium Red, Light Red and a dark "grayish-brown" made of Light Red and Phthalo Blue.

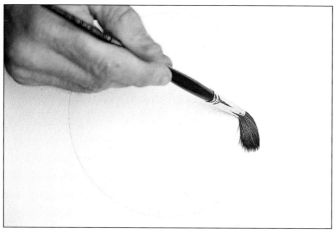

Draw a circle and wash it in with clear water right up to the inner edge.

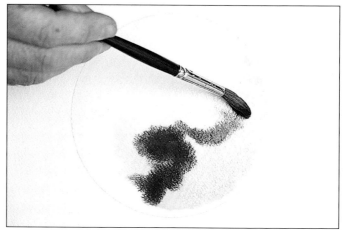

Working with the paper flat, introduce one color after another, leaving some white areas.

Landscape exercises

Now let's start to apply some of the washes in one or two small traditional landscape paintings. They may seem very alike, but will successively build your understanding of the potential of the basic principles. Once again I suggest you work small at first.

EXERCISE 1: "EARLY LIGHT OVER THE BLUFF"

For this little painting you'll need to mix up a single color. I mixed Payne's Gray which is ideal for working in monochrome. (Make sure it's artist quality paint of course.)

Have a look at the steps in this process first. You'll notice that I varied the composition each time so that you wouldn't worry about making your painting "the same" as mine. Let it represent the sort of landscape it wants to represent.

Start with a gradated wash. THIS, AND EACH SUCCESSIVE WASH, SHOULD RUN RIGHT TO THE BOTTOM OF THE PAGE.

When this is completely dry, start the second wash at the upper edge of an imaginary range of mountains. If necessary, do a little trial sketch in pencil on a scrap of paper to get ready for this, but for this exercise DO try to let the range appear as if by magic, with its own life. Grade it decisively (and all the way to the bottom of the page), allowing it to give the impression of mist in the valley; but don't force it to do anything it doesn't want.

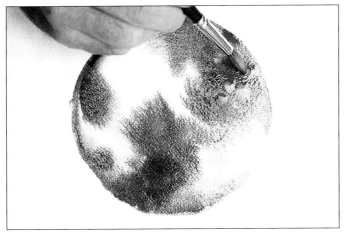

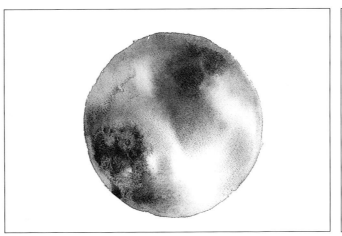

The hairdryer controversy

If you allow a wash to dry naturally then the resulting granulations will be much more impressive than if you hurry things along with a hairdryer. Up until now I've been suggesting the hairdryer to help you speed things along, but this process tends to flatten out granulation. With experience you may discover how to tease only some areas of a wash with the dryer, to create a surface which combines both granulation and a velvety softness. This is an effect which you can use in studio work to evoke all sorts of creative landscapes. On the other hand, careless work with the dryer can ruin a watercolor. You'll have to decide for yourself!

Experiment as you go along. Closely observe the results as your colors intermingle. Raw Umber and Ultramarine granulate particularly well. If you charge an area of one with the other, or lay them in next to one another, anything can happen!

When you lay the colors in, do try to avoid disturbing the action with unnecessary brushwork. Now, all you have to do is to allow the result to dry flat.

After this is dry, make the next gradated wash creating a landform closer to the viewer.

Then when this is dry, make an area of flat wash to create a slope in the middle-ground which you tease up from the upper edges to create silhouetted trees or grass.

After you've absorbed the process working on tiny sheets, try it out on a slightly larger scale. Here's a bigger one, painted on an exercise sheet.

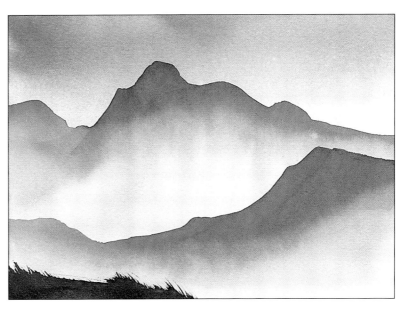

EXERCISE 2: "FALL"

This time the gradated washes are made with different colors. Just as before I varied my composition to release you from "copying". Start with a gradated wash in Cobalt Blue.

The next wash makes use of the gray made up by mixing Light Red and Cobalt Blue.

Next, create the foreground slope, using a green wash (made by adding Hooker's Dark Green to Yellow Ochre).

For the final wash, use a darker brown, made by combining Phthalo Blue and Light Red. Tease this upwards with a stiff bristle brush (any stiff brush you like should do it). Create simple shadows running down the facing slope of the distant hills. Shadow the mountains with their own color (the gray made from Light Red and Cobalt Blue).

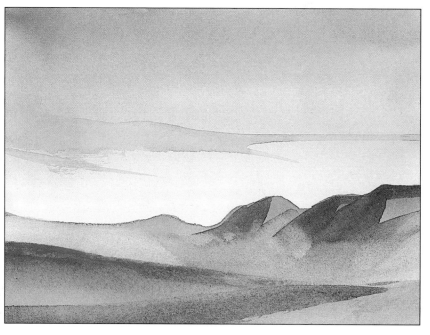

To create the clouds in this slightly larger version, I loaded a fan brush with the shadow color and dragged it sideways across the sky. I then lifted some of this color with a tissue before it dried.

EXERCISE 3: "DISTANT FORTRESS"

This time begin by laying a gradated wash from bottom to top. This manouver is not as complicated as it seems if you turn the picture upside-down. (Just reverse the board.) Use a warm color for this first wash. I used Cadmium Orange Medium. Allow this to dry.

Reverse the board (put it right way up again) and lay a gradated wash in a cool color. I used Indigo.

When this is dry, lay down a range of distant mountains using Lamp Black to create a stark silhouette against the warmth of early morning light on a clear day. Done. Easy as that.

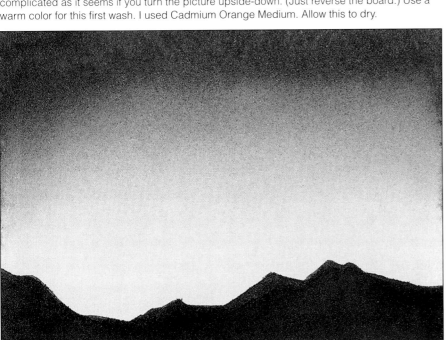

"Be your own painter and adapt what you want to your own work."

EXERCISE 4: "SUNSET OVER THE VALLEY"

Now let's combine all of this into a small landscape. Again, my stages look slightly different because they were individually painted.

Start with a flat wash of a Yellow Ochre.

Next, lay down a gradated wash in Cerulean Blue working diagonally from, and largely restricted to, the upper corner.

Now lay down a range of gradated mountains using the gray and Cobalt Blue and also variegate the wash as you move across the range.

Now variegate the foreground using whichever colors seem most appropriate. I used Yellow Ochre, Cobalt and the gray.

To give the mountains form, lay a shadow wash over them, variegate it as you go and soften the lower edges by grading them. There's no need to bring this down over the foreground, just dab it at the edges with tissue to lift and soften the edges.

Repeat the shadow process to create greater detail. If you add a foreground area in a dark wash this will give the viewer a point of entry into the landscape.

After this is dry, reverse the board and lay a gradated wash in Light Red away from the upper edges of the distant mountains. This introduces you to a new technique. Wet the sky area into which you intend to lay the Light Red using clear water (up to the edge of the mountains). Remember the pond analogy, and try not to stir up the delicate washes underneath the water. This is very important during the next stage when you load up with a little Light Red (just dip the brush tip to load it) and charge this wetted area. The color should seem to explode away from the edge, blending to give you a gradation which flows out over the wetted area of sky. If you see hard edges forming, then dab them lightly with a tissue without wiping (which would disturb the submerged lower washes). This process may be greatly assisted by using a hairdryer. But that's risky until you pick up the knack of it. Just make sure that you angle the airflow towards the mountain edges. Do it the other way and hard edges will form in the wrong places.

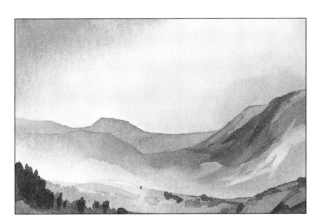

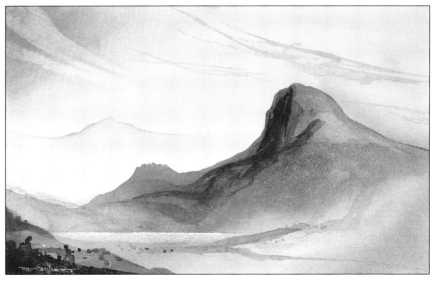

Here's a sightly larger and more fanciful painting using the same basic processes and taken a little further using techniques you'll meet in the next chapter.

Turn the whole thing the right way up and add dry brush shadows and details to the foreground. You can also lift out lights by wetting the dried wash here and there and then wiping out with a tissue. Finished! The result is a small but complex painting using a broad range of traditional basic processes.

CHAPTER 6: MAKING MARKS

Think of your landscape as a drama

Creating a watercolor landscape from your imagination is a little like setting up a theater set. If you think of the sky and clouds as the backdrop, then mid-range elements like mountains, forests and lakes will be the supporting cast. Within this environment you have many options when it comes to arranging your principal actors — or perhaps a single "star". You might want to arrange things so that all eyes will be drawn to one feature, which might be a forest, a tree, a rocky outcrop, or whatever you choose. You're the director, and so you can set things up according to your own sense of drama. Then there's the possibility of dramatic lighting — from a *fortissimo* wet-in-wet sky. Whatever you like!

Everything depends on your brushwork
None of this will happen unless you know how to use your brushes. The backdrop sky may require you to paint broad washes with sweeping brushwork; the supporting cast might require tightly defined areas of complex wash, while the lead in your drama may need fine detailing. Who knows? So you have to be ready for all of them.

There are unlimited possibilities
Most brushes are capable of creating an almost unlimited variety of marks, a fact which surprises many people who have never experimented with their brushes. When you pick up a brush it should come to life in your hand, taking on a life of its own, and often suggesting

creative possibilities to the painter.

You already know how to lay down the basic washes, so let's try a few simple exercises in creative brushwork. You may be surprised at the variety of interesting marks that will cover your painting surface by the time we're finished.

Washes tend to require forethought and order but mark-making requires free-thinking. You have to experiment in order to build up your repertoire. And the bottom line remains, "What can you do with these marks? How will they help you to paint the things that you see, and want to paint?" In this chapter I'll show you how to bring your brush to life and how to excite the surface of your paintings with all sorts of marks that you can use.

Bringing your brush to life
There's a world of difference between simply *using* a brush, and painting *with* it, for the latter implies a partnership between brush and painter. And the first problem in brush-handling is very often the mind-set which has been well established by years of holding a pen

for writing. Somehow we have to free the brush so that it will dance across the page as if it were alive in our fingertips rather than trapped by them!

Watercolor books often feature pages of brush experiments which illustrate the types of marks at your disposal. These invariably look rather formal — like those little footprints you see on charts illustrating dance-steps. Unfortunately, the hand movements that made them cannot be seen (unless you're watching a live demonstration or a video). Nonetheless you can free-up your brushwork without watching a demonstration. There are no rules, no right or wrong ways to use your brushes, and no limitations to your creativity once you release this "genii of the brush".

If you've never experimented with your brushes before I still suggest that you start with one or two rather formal exercises. (We'll work on freeing up the hand later.) You'll need to have all your brushes handy; some dark wash (I suggest Payne's Gray) and some newsprint and watercolor paper.

Brushwork is fundamental to almost everything.

START WITH YOUR FAVORITE BRUSH
Using your favorite brush — a large sable is ideal — explore the types of marks you can achieve using the dark wash on some newspaper. Try dotting, dabbing, dragging and rolling for starters. Allow the brush to find its own balance and experiment with ways to hold it in your hand.

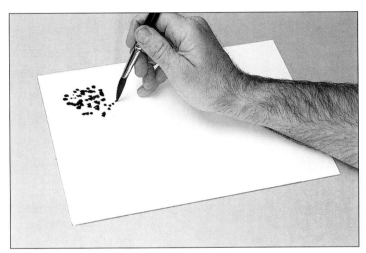

DOTTING
Dotting is simply morse code with a brush tip. Vary the pressure to vary the character of the mark.

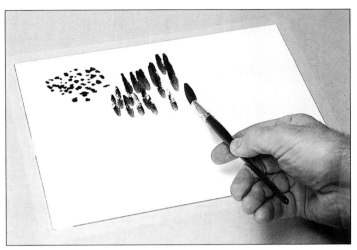

DABBING
Dabbing, for want of a better word, is even easier; simply pat the paper with the side of the brush and lift it straight up again.

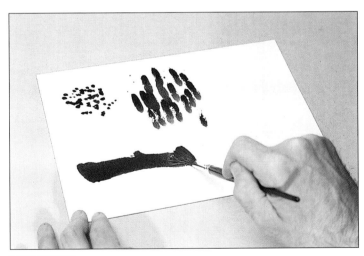

DRAGGING
Drag the brush sideways across the sheet.

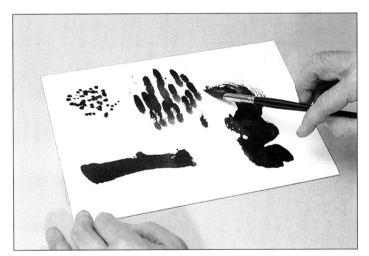

ROLLING
Roll the brush while working it upwards against the hair. Be careful not to damage the hairs by digging the ferrule into the paper.

Now try with other brushes

Notice the difference between marks made with different brushes, and with the brushes fully loaded and almost dry. You'll create different types of marks even within the limitations of "dot, dab, drag and roll".

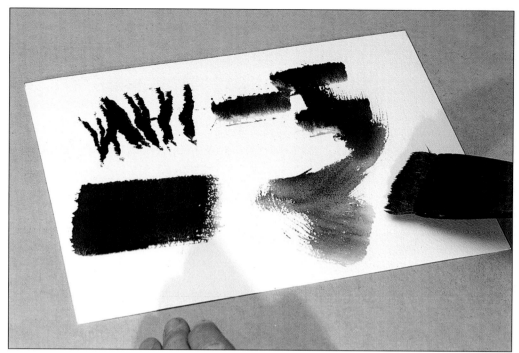

Sweeps from a hake brush.

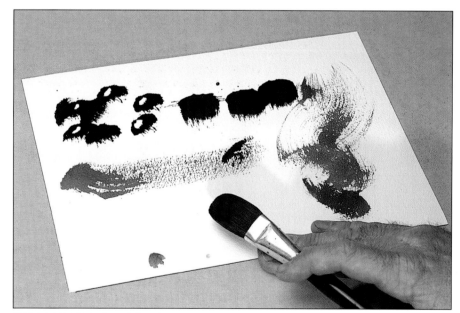

Marks from a broad wash brush.

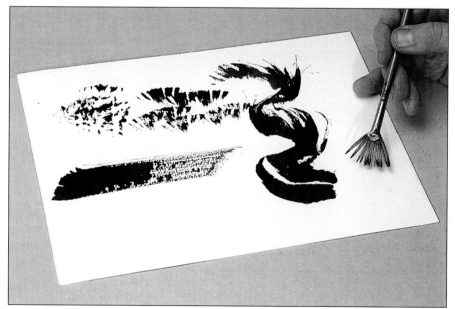

And the interesting marks from a hog hair fan brush.

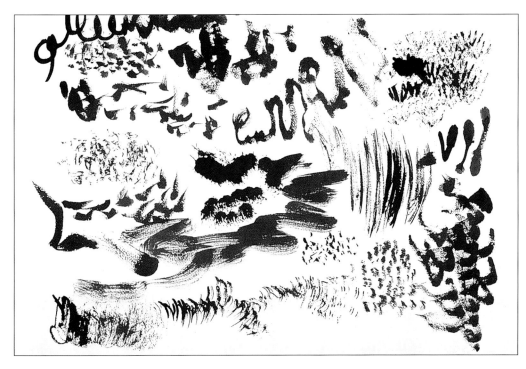

FREE MOVEMENT TO A RHYTHM OR A BEAT

"Dot, dab, drag and roll" were only to get you started. This next step may seem a bit zany, but it works! Ask someone to help you by tapping out a variety of rhythms and beats — everything from a staccato to a slow thump, using fingertips, fists, a pencil (or anything!), while you try to keep up by matching the rhythm with your brushwork. The more excited they get, the more excited you get!

You may end up with myriad dots or groupings of marks; with broad slashes or even stabbing marks. It doesn't matter. What counts is that the brush should begin to move more freely as it responds to the challenge of keeping up. Freed from holding and moving the brush in any pre-set manner, and from feeling that you have to use logic to make each mark, you regain a childlike freedom.

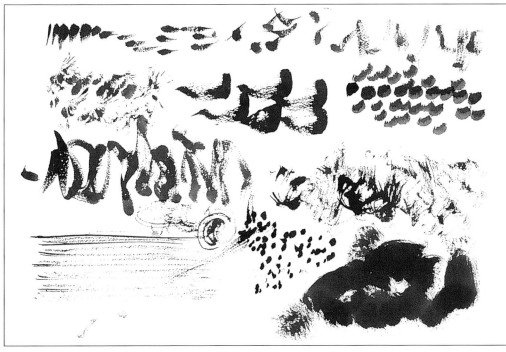

Using marks to create trees

There are lots of ways to paint trees. Every artist has their own favorites. Here are a few suggestions to get you started on developing your own.

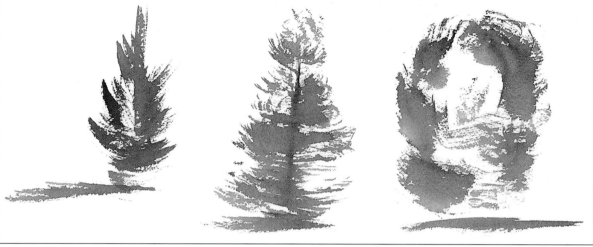

Here are a few tree silhouettes created by dotting and dabbing with a hake. As marks they suggest types of trees; but they also reflect the character of the brush AND hint at the types of hand movements that were required to paint them. Try a few freehand brush silhouettes of trees using different brushes. Try a few from photos and then make them up.

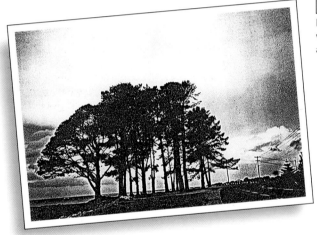

This is a photocopy of a color photograph. Reduced to black and white, the group of trees becomes a silhouette against the sky and it's easier to see it as a pattern comprising dabs, dots, splodges and all sorts of other marks. Combined they tell us, "trees!" Learn to see trees as shapes and patterns of brushmarks.

Simple shapes at work
Trees can be as simple as blobs receding into the distance.

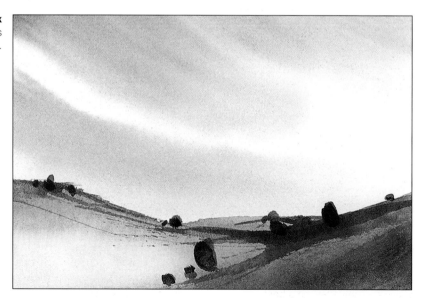

Three-dimensional tree shapes can be suggested by loading a brush with two tones of color, or by dabbing darker color over a lighter tone.

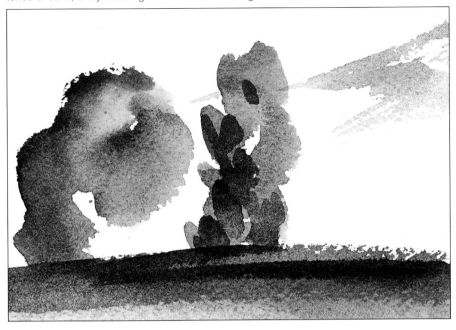

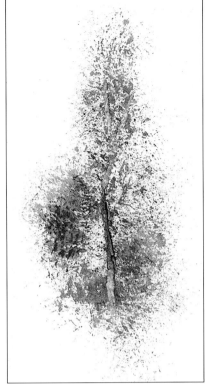

Another easy way is to stamp the tip of a brush up and down to "stipple" the shape and then, before it dries, scrape out a simple trunk with a knife-blade.

AN EXPERIMENTAL APPROACH

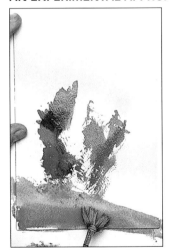

Load up a brush with colored wash and quickly establish the simple silhouettes of two scraggly trees on a bank.

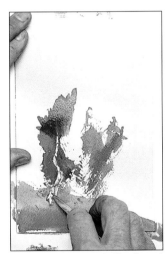

Using your pocket-knife, drag through the wet foliage to establish the trunks and maybe a few branches.

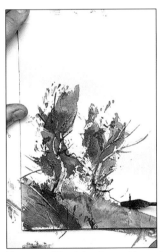

You can still add color wet-in-wet at this stage and while it's drying you can drag out twigs or branches from the foliage with your pocket-knife, brush, palette knife or anything similarly scratchy.

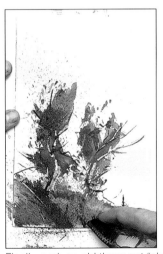

Finally, grab an old throw-out "shaggy dog" toothbrush and load it with wash. You can use spatter to excite the foliage or the bank, even to create a haze of insects in the air around! Experiment, let the trees grow of their own accord and see what happens.

MONOCHROME TREE STUDIES

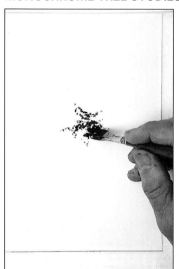

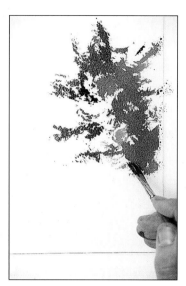

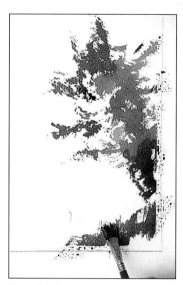

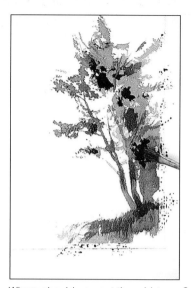

Using the technique known as SPLIT BRUSH, tap out the foliage using the end of the scratchiest old bristle brush you can find. Think of the foliage as a pattern of marks.

Build it up until you have established the mass of the foliage.

Establish the grassed area below and in shadow. Next, join the foliage and grass silhouettes by dragging in the trunks and branches and then add the mid-tones and further details.

Where should you put the mid-tones? There's no right or wrong. (Try using them to build the shadowed areas; on the trunks, on the grass and in the depths of the foliage.)

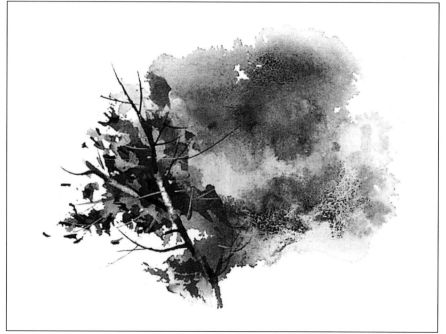

Let granulation help you with the details
Charge areas of wash to create patches of granulation that hint at foliage and, when you start to imagine it there, pursue it with your brush, dabbing and lifting until it "grows" as if with a life of its own.

WET-IN-WET FOLIAGE EMERGES FROM THE WASH

Wet the sheet, then create a cloud-wrapped environment using Payne's Gray and Ultramarine Blue.

Suggest the blurred forms of nearby foliage and land by introducing Yellow Ochre and Raw Umber, then build up form with Payne's Gray and the brown-gray.

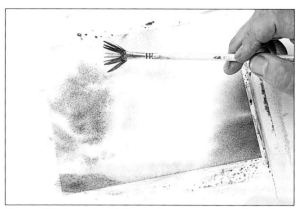

It's possible to work with these shapes using a variety of brushes, charging areas of wash with other colors, dropping in clear water, and so on. (You could also use the blade of a pocket-knife to drag out trunks, grass and other details at this stage.)

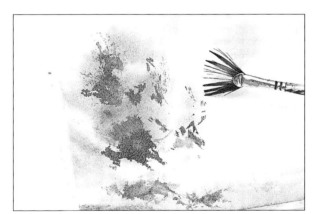

Allow the work to dry. If you use a hairdryer to hurry the drying you may create more exciting effects, but will flatten the granulation. To preserve the granulation, allow the pigments to mingle, settle and dry before using the hairdryer.

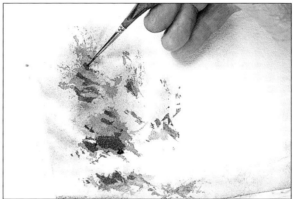

Build up trunk and branch structures by "lifting" details and by adding details in darker colors. From this point on there is no particular process . . . you really do have to work within the watercolor and allow it to evolve in its own way!

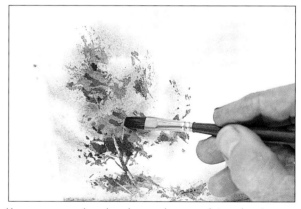

You can use various brushes and appropriate colors to flick in leaves and twigs, distant silhouettes of trees and other paraphernalia of your chosen landscape. I will use an old fan, a fine sable, a tired old stippler brush and a pocket-knife.

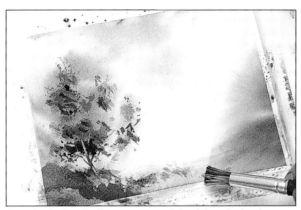

The stippler brush allows you to work back into the landscape.

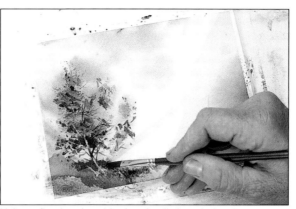

Using a fine brush, add crisp details in a dark color.

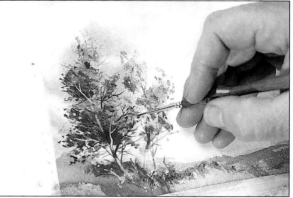

Now mix up a little bodycolor (by adding Yellow Ochre to Chinese White), and then flick in a few crisp details: twigs, errant blades of grass, a tiny bird against a dark tree — whatever you think appropriate. Be aware when you do this that these details may appear to leap off the page; but using bodycolor also enables you to add details where they would otherwise be impossible. This is a traditional device and acceptable in moderation (except to some artists), where you use the fact that gouache sits on the surface of the page to great advantage.

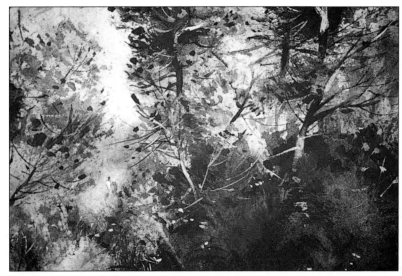

Here's a close-up of detail in a similar painting. This is not a view of a real place. It is, in fact, a painting from the imagination, because it virtually grew out of foliage suggestions made within the wash by the granulation of pigments.

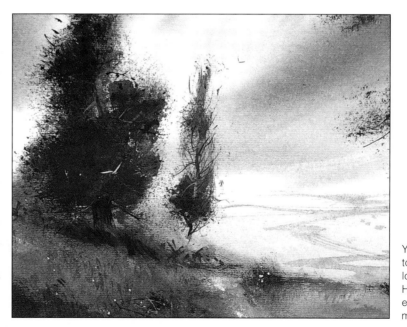

You don't have to use a somber, low-key palette. Here's a small experiment with a much richer palette.

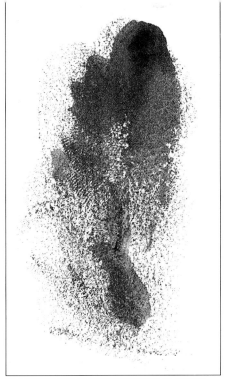

Simple grass using wash and blade

This is an easy and effective way to paint grass. First, suggest the area with variegated wash, then use your pocket-knife to flick out individual blades. When the wash is very wet this should cause a darkened line to appear. But if the wash is nearly dry, the same blade will probably push aside the wash, exposing the paper and leaving a light mark.

Let the wind move your brush

Whenever you paint grass, remember that wind direction should be reflected in the character and direction of your brushmarks. Imagine the grass responding to the wind; and let the brush respond to the grass.

EVEN MORE INTERESTING MARKS

The great watercolorist J.M W.Turner even used fingerprints to suggest foliage! Here's the beginning of a tree shape built up the same way. There is no end to the things you can use to suggest detailed foliage, grasses and trunks. Try traditional brushes, mutilated, stiff and scratchy old brushes, blades of all sorts, twigs, feathers and even "shaggy dog" toothbrushes. ANYTHING that makes an interesting mark!

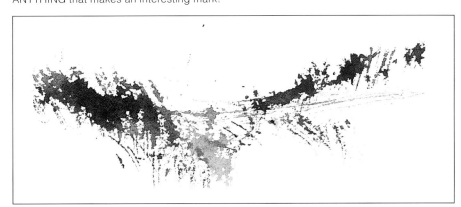

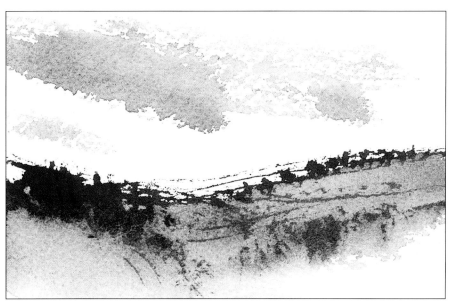

COMBINING MARKS AND WASH TO CREATE GRASS

Use a stipple brush, or old hog hair brush, to create the pattern of grass on a rolling slope. This time try to imagine you can feel the slope beneath the brush, so that it skips over the surface of the page as if exploring both the contour of the land and the rhythm of the grass.

When this is completely dry lay a variegated wash over it. I added a few streaks of blue to suggest the sky.

FOLIAGE, GRASS, SHADOWS AND TRUNKS

Here's an example painted in dry-brush using three tones. If you also count the areas of reserved white there are four levels from white to dark. This is a very easy effect to achieve using a hake loaded with tonal values of a single color (in this case Payne's Gray). The lightest gray was applied first leaving patches of broken white. The next application (the middle-gray) created broken shadow playing across the field. The final details were flicked in with a fine brush and the darkest tone. These suggest the type of grass, and can be used to show wind movement or passages through the meadow.

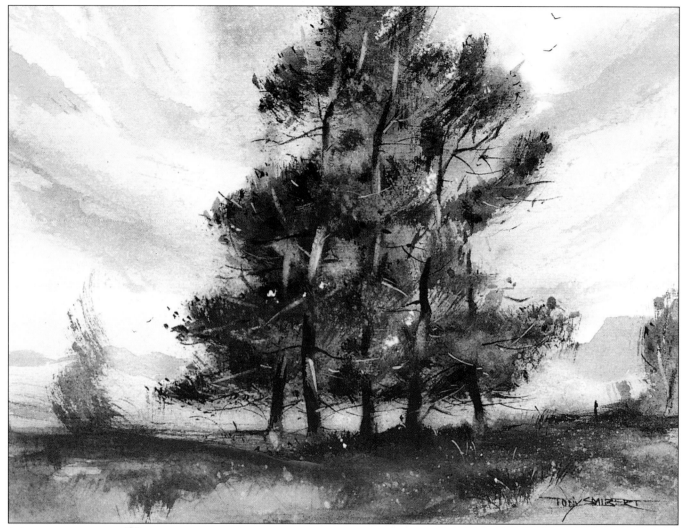

Painted on an exercise sheet, this is a small, imaginary study of trees in the fields not far from where I live — not particular trees, just the sort of trees you see in groups there. It's really a brush drawing with wash which is a very traditional way to work. I've tried to unify the textures and shadow areas throughout, particularly the shadowed parts of the tree and the shadowed areas of grass beneath them. Once you've established this, it's not so hard to blend the shadowed patterns of the grass out and away from the tree(s). I lifted out the trunks where they cross dark areas of foliage to make use of COUNTERCHANGE (light on dark, and dark on light). Without this the trees would simply read as a massed silhouette (rather like the photocopy earlier on).

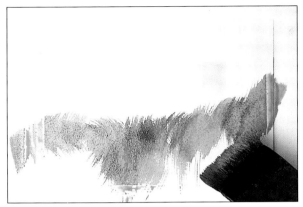

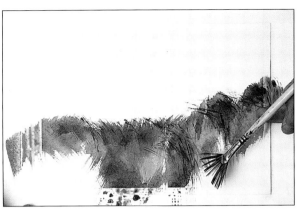

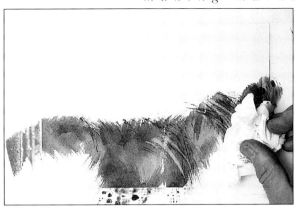

COMPLEX GRASS

It's possible to load most brushes with more than one color. Here's how to do it with a hake. First dip one end (about half the hairs) into one color, then the other end into another. The brush is now loaded with two colors. Now touch the outside edge of either or both ends into further color(s). I loaded my brush with Yellow Ochre, Light Red and a green to make the first strokes.

Suggest darker areas after dipping the brush into a rich brownish-gray made by mixing a wash of Light Red and Phthalo Blue. Details can be flicked in — I used my old favorite, a mangled fan brush.

Add similar strokes from the fan to the dry surface, but with clear water this time, and then quickly but firmly wipe away with tissue to "lift" out lighter blades of grass.

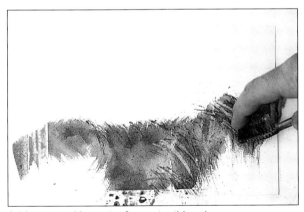

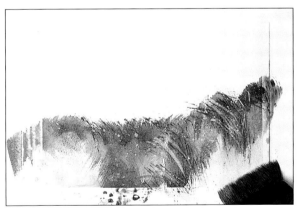

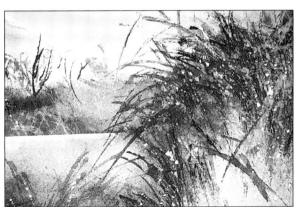

Add texture with spatter from a toothbrush.

After the details dry, color can be washed over the top — try Yellow Ochre as I have done here.

Drag out "lights" with a wet brush (then lift with a tissue) or use the blade of a knife. It's a great effect, giving you different results as your wash goes through stages of drying.

Here's an experimental area painted this way showing lots of possibilities.

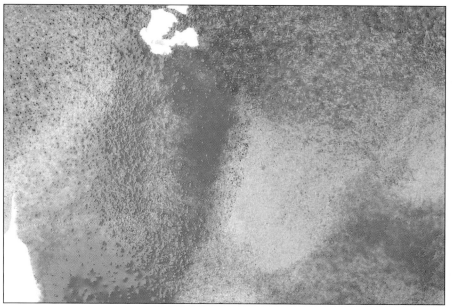

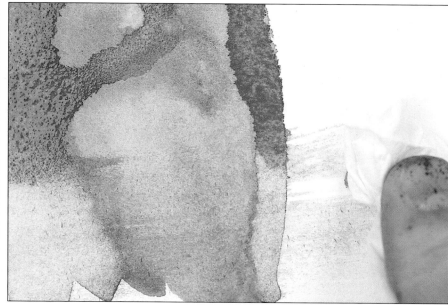

MARKS IN ACTION

Let's put some of the mark-makers on your table into action in a few small color studies. Where better to start than with a freshly painted area of variegated wash which is granulating and already beginning to dry?

Quite often one area will dry before another. Try interrupting the process and wipe with a tissue, as I have done here. This can be a great start for rockfaces and mountains.

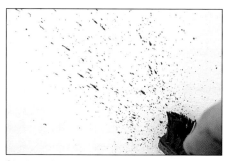

Single-color spatter has possibilities.

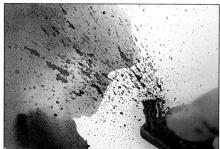

Experiment with spatter over a variegated wash.

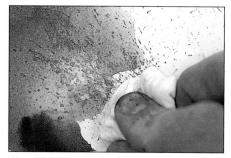

While it's still wet, wipe it hard to lift areas from the wash. What does this suggest? Part of a rockface perhaps?

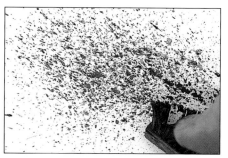

Multi-colored spatter has more possibilities again.

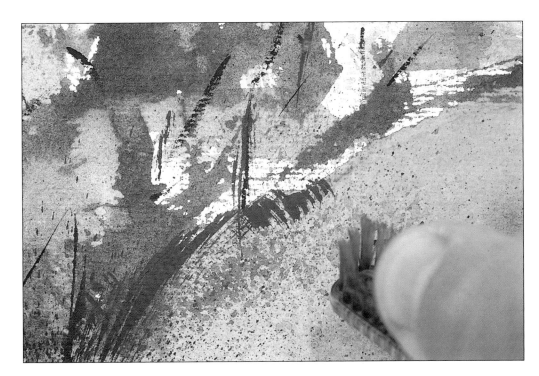

Next try spatter over an area of broken wash and dry-brush to add texture to a foreground area.

Use a blade to scrape back the paper surface and lift a shining lake from a dark scene.

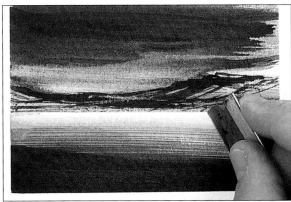

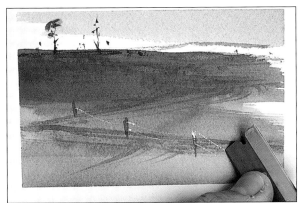

The sharp point will create the shining strands of a wire fence across a pasture.

A tiny dab of bodycolor was often used by the English School of watercolorists to bring figures forward.

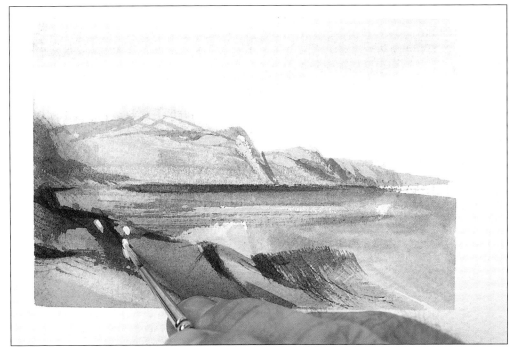

53

A rigger is the perfect brush to create almost calligraphic birds.

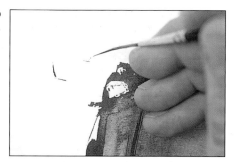

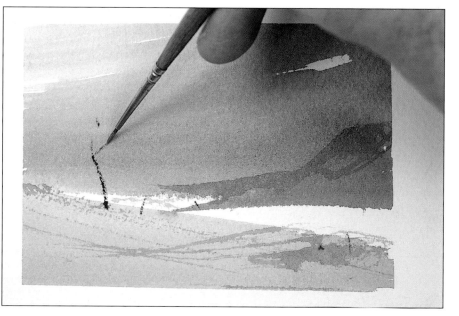

A fine sable brush can be used to add details at any time.

Your pocket-knife is perfect for dragging out rugged whites and to pick out bright spots of white to enliven any surface.

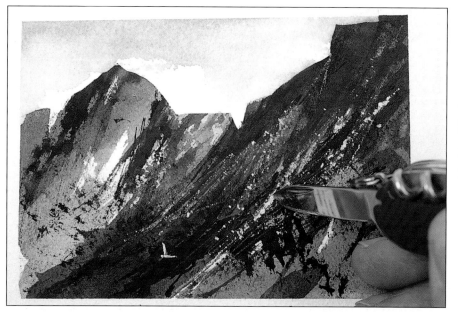

A stipple brush is great for adding foliage to the simple shapes of trees.

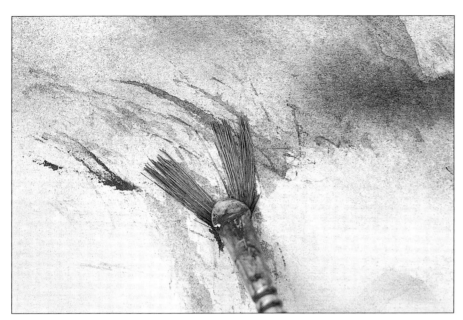

An old hog hair fan brush can be used to create a wide range of effects — like these windblown grasses.

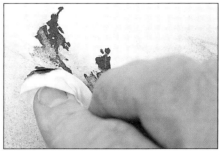

Tissue is invaluable for softening recently added details — in this case, trees in mist.

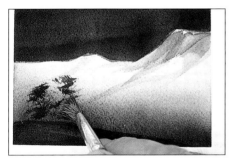

A hog hair brush, used almost dry, can be used to create the dark shapes of trees.

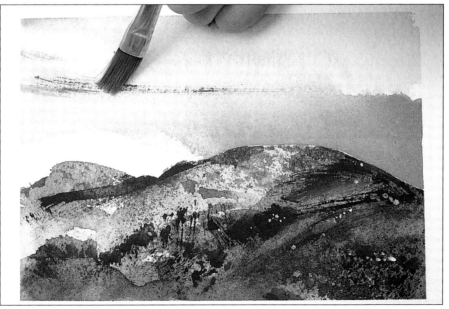

And here's that pocket-knife again, creating a rugged tree-trunk.

A nylon (or similar) flat brush is perfect for lots of uses but, here, for dragging in a dry-brush cloud.

55

CHAPTER 7: COMPOSITION IS EASY

How to select, arrange and combine visual elements

Why is it that some paintings look just right while others don't please the eye at all? Very often the answer comes down to one word — composition.

Without some consideration of composition, even your most beautifully painted landscapes may fail to please. As a keen photographer, I know how disappointing it is to return from travel to some beautiful location only to receive back from the lab photos that simply don't do justice to my experience of the place. The camera doesn't lie; but it does reduce a vast landscape to a tiny flat piece of paper with a few shiny colors on it! How can I improve my travel snaps? The answer is simple: stop taking snaps, and start using the rules of composition to guide me in selecting which things to put into the photograph and which to leave out.

Photographing for information is very different from photographing as an art form. If I simply want to record the shape of a tree or patterns on an old rock wall I usually just hop out of the car and take a snap. But when I want to capture the sense of isolation that surrounds a single tree on a vast, arid plain I really have to think about how to place the tree in the photo so that I can see its relationship with the far horizon, the great vault of the sky above, and so on. I try to capture the *emotional impact* of the moment, and I hope that my photograph will help me to convey my feelings and impressions to other people later on.

To do this I move around, using the viewfinder to see what the camera sees, possibly dropping to one knee so that the tree is silhouetted against the sky. Or I may end up lying in the dust so that nearby grass or rocks create a foreground interest. I consider the light, effect of shadows, everything, before taking my photo. The one thing I don't do is snap!

When painting I have even more freedom to select what goes in or out of my paintings. When you create landscapes from your imagination, you have complete freedom.

Think of it this way. A musical composition is a series of sounds brought together to create a total effect. Similarly, in a painted composition you select, arrange and combine visual elements to create a whole. You can choose to create an harmonious effect, or you can create a discordant or unsettling effect. It's like cooking — everything that goes into the pot has some effect on everything else.

This means, for example, that when you detail the foliage of a tree, you remain aware of the impact that each new mark is having on the total picture. In this chapter I'll show you how this works.

Composition is easy. There are lots of traditional principles that you can use to build up confidence until, eventually, I think you'll find that you can rely on your own instinct to tell you what should go where.

I'm going to show you:
- How easy it is to understand the traditional principles of composition;
- How to apply these to your own work; and,
- How much you already know about composition — and how come you didn't know you knew it!

Let's start at the beginning: with an empty picture plane. You may like to work through this exercise with me by cutting up a piece of black paper into various sizes of rectangle.

Start by placing one of them into the picture plane at the most obvious, considered, ordered and man-made location you can think of.

Odds are you've placed the rectangle right in the middle. In fact, I'll bet that if you look through your sketchbook you'll find lots of sketches occupying the middle of the page too. It just seems the logical place to start to put things, doesn't it?

Whether small, like this, or larger like the first piece, our rectangle is a positive element in the neutral space which surrounds it. Painters have to consider this empty, negative space all the time. The slightly smaller rectangle seems a little nervous about its surroundings — it's keeping away from the walls!

With a larger rectangle the relationship between the black and white is even easier to define. The black outer edges lie parallel to the perimeter of the picture plane, the corner angles relate to adjacent corners and the spaces above and below the rectangle are the same size and proportion, as are the spaces to left and right. It's formal, safe, stolid, predictable and . . . obvious. That's why the urge to work in the center of the picture plane is so strong and, let's face it, so boring!

This is a little more exciting. With the rectangle turned to the vertical the spaces around it are now more varied. Yet we still haven't taken any real risks.

Now this is a little more risky. The rectangle is slightly askew. Although it still dominates the center, it's showing more interest in its surroundings and seems to have taken on a life of its own. Gone are the parallels, aligned corners and equal spaces; it's now more independent than it was before, even though still located in a very conservative position.

Do you notice that two objects in the center still read as one, despite the space between them?

Even an interesting shape made up of lots of rectangles tends to fail if it's simply stuck in the middle.

If I asked you to place an object rectangle within the picture plane at a position which would create a vast sense of space, where would you choose? My guess is that you might head for a corner.

But the moment you place another rectangle in the opposite corner they start to speak to each other across the space between. Your awareness of the space that divides them is heightened, as it might be if the rectangles were a couple sighting each other across an empty dance floor.

Here, the larger form appears more dominant, as it might if it were a cat and the other a mouse cowering as far away as possible.

Now, in moving away from the corner and towards the center the larger form has changed the spatial relationships entirely. The larger form now seems even more dominant, perhaps even threatening.

All these examples simply illustrate that all elements within a given picture plane relate to each other. But, even more important than that, they relate to the space they occupy. This is elementary to the principles of composition.

Informal and natural placement

It's actually quite difficult to position these rectangles so that their relationship with the space they occupy does not seem contrived. The urge to organize and formalize is pretty strong, so let's see what happens if we try out a different approach and let a rectangle fall where it will. This time the spacing is completely different — it's informal and uncontrived.

The informality is sustained when a second rectangle is added.

And when you drop another and another, they overlap forming interesting shapes. Like leaves settling on a pathway, they create a composition which does not seem contrived. One of the biggest challenges facing the painter who creates landscapes from imagination is how to organize the composition so that the resulting picture retains the informality of natural placement.

Up until now we've limited ourselves to the confines of the picture plane. In reality, when you drop lots of paper some of the pieces may land off the sheet and others along the edges. These will start to lead your eye out of the picture (suggesting a world that continues beyond the edge of the page) and they can also lead you back into the composition.

Even though I have cut off all the overlapping pieces, the suggestion of greater space beyond the edges remains. These renegades still carry the eye into and out of the picture. Compositional elements need not stop at the edges of a picture. You can use them to deliberately lead the eye and to hint at a greater space beyond the picture plane.

Balance

I still remember my art teachers talking about "balanced composition", and the term confused me at first. So, let's look at *balance* for a moment. Think of the two black rectangles shown here as the main elements in an abstract composition. Think of the brush as a see-saw and the triangle as the pivot, the fulcrum on which it balances. Two objects the same size, at an equal distance from the center will balance perfectly.

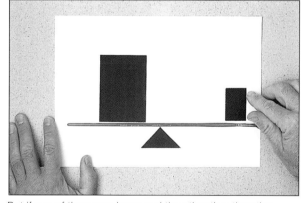

But if one of them was huge and the other tiny, then the huge one would have to shift nearer to the center and the little one away from it to retain the balance. Consequently, to create a balanced composition you will find yourself considering the relative weights of the elements you place into it. At its simplest, this principle applies to the relative sizes of objects (landforms, trees, cloud shapes, and so on) but at more complex levels you will also certainly find yourself balancing the relationships of less concrete visual elements such as color, tone and texture. Don't let this worry you! Cultivate your gut reaction to balance and learn to trust your artistic instincts. They're just waiting to advise you!

The Golden Section

For centuries, generations of Western artists have practised a principle known as the GOLDEN SECTION. The placement of the black rectangle below conforms to that principle. Sometimes called, in its simplest form, THE RULE OF THIRDS, the Golden Section is worth knowing about because it is one of the easiest compositional principles you can apply to landscape. If you were to look back through any major reference covering Western Art History you'd find countless examples of it in use. Here's how it works.

Sketch a number of small rectangles on to a scrap of paper as I have onto the following pages. Think of each as a small picture plane. Roughly try these experiments. Take one of them and join the top to the base with a vertical line. Place this somewhere from a half to one-third of the way across from either side. Then repeat the process about a half to one-third of the way down from the top (or up from the base). That's all there is to it. (Though people who've studied Pythagoras might not be absolutely happy with my description!)

If you apply the resulting grid to landscape it's a pretty safe bet that anything placed where two such lines cross will seem to harmoniously relate to its space. Like this tree, for example.

"Your greatest challenge is to organize the composition so that the resulting picture retains the informality of natural placement."

If you place the tree in the middle it dominates the space and does not encourage us to see it as part of a larger landscape which also includes other elements. (Remember that desert tree which I wanted to photograph earlier?)

How does this principle affect the horizon? A centrally placed horizon divides the picture into halves. Then, if you place a mountain on it (in the middle), and a tree in front of it (in the middle), the result looks like this! (Remember when we lumped all those black rectangles together in the middle?)

But if your horizon is positioned according to the rule of thirds and the mountain and tree are worked into it then the result is an easy success. The only problem is lots of people use this principle and so the result can be a sameness. However, the "up" side of knowing one or two conventions is that you now have the option of using them to help you in your first attempts to create original landscapes.

This is not a book about composition, but here and there you'll find compositional devices at work that a great many artists have applied from time to time. Don't be tied down by formal composition though, because for every great painting ever constructed using traditional composition there probably exists at least one other that completely defied convention — yet succeeded in its own right!

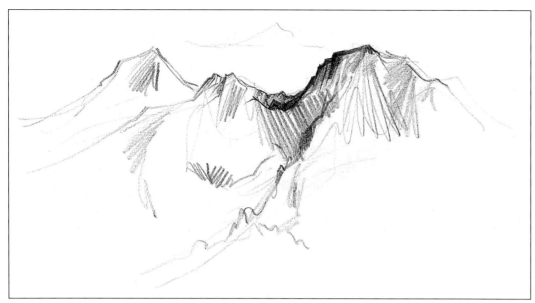

Preliminary sketches are your greatest tool
When you make "first impressions" with a pencil you'll not only generate lots
of ideas but you'll resolve many compositional elements at the same time.

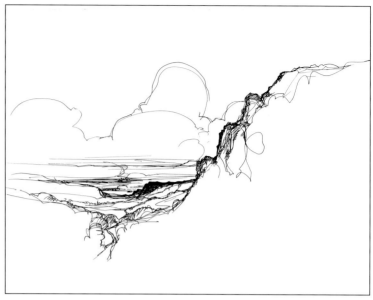

Power doodling
Time spent doodling with a pencil is great fun. Why not let those doodles
turn into imaginary landscapes? You may be surprised at what creates itself
on your page! Such imaginary landscapes are evidence of your creativity
flexing its muscles and are only a beginning.

Creative sketching in pencil

While we were planning this book, my publisher said to me, "You know, we've got all the computers in the world in our office; but none of them offers us the creative options that a pencil does!"

He then explained that he does most of his own creative planning in pencil first, even though he has the latest computer layout and design programs at his disposal! He returns to the computer only after he has planned each book. The computer makes the book happen but just doesn't offer him the creative options of the humble pencil!

This left me thinking that I've taken the pencil for granted, even though it's certainly one of the most powerful tools at my disposal — one that comes into its own when I'm playing with the creative possibilities of a subject. And it becomes a "power tool" when the serious planning starts and I'm sorting out the compositional elements of a watercolor. I may paint in watercolor but I do most of my planning in pencil!

In the middle of a watercolor, the pencil is always ready to help me to try out a detail that I want to add in watercolor. And I can rub it out after I've washed this in. It helps me to see what a distant mountain might look like without having to commit myself. It's fantastic.

Lots of watercolor ideas come to me when I'm working in pencil. Like most painters, I always spend lots of time drawing — sketching, doodling, gathering information and visual impressions, and pushing these impressions around before I go anywhere near my paints.

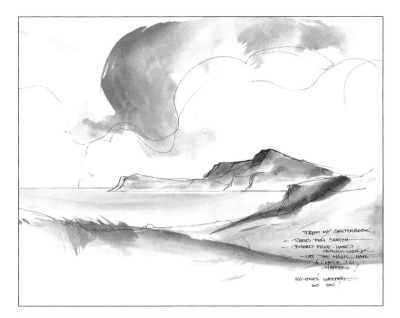

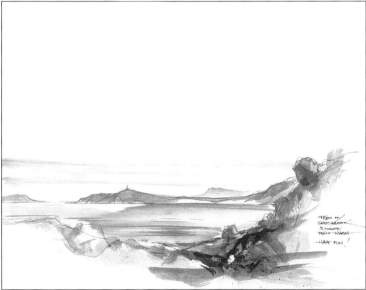

On-the-spot sketches

All this note-taking will pay off, especially when you start to work from your imagination. Those impressions you recorded are not only on paper, they're in your memory too because of the way that memory works. The act of sketching helps the brain to secure experiences in that "inner library" we talked about earlier.

TRAVELING VERY LIGHT

Pens and pencils are perfect to carry in your pocket. J.M.W. Turner, the great English watercolorist, also used to carry tiny scraps of rolled up paper in his pockets to jot down his impressions in pencil. (He said he could do 14 pencil sketches in the time it would take to do one in watercolor.) In our era, the back of a business card is a great alternative, especially if you get caught without your tiny sketchbook.

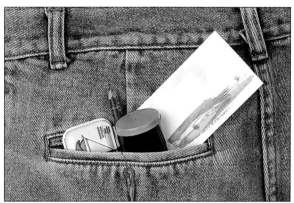

Studio in a pocket
If you're really into traveling light but can't bear to leave your watercolors behind, here's the answer: a tiny boxed set of pan paints borrowed from my kids, a business card or two, a film container and a pencil.

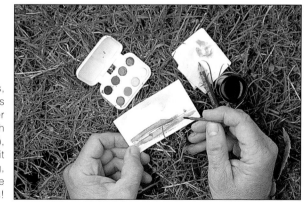

At work on the grass, the film container turns out to be a nifty water jar (you can also wash the brush in the lid), the tiny brush in the kit is OK for sketching, and tissues complete your requirements!

63

BUILDING A LANDSCAPE "FROM THE GROUND UP"

Unsure where to start?

You may find it a useful beginning to start with a straight line as a sort of horizon (and a compositional beginning).

Above it draw a range of gentle foot-hills.

And beyond that another. Notice how each one rises from behind the one in front?

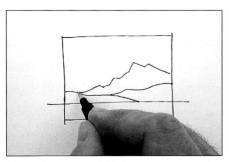

Above those you might draw some rugged mountains. Go on, make them up, no-one's watching.

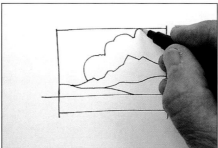

Beyond this there might be a bank of clouds.

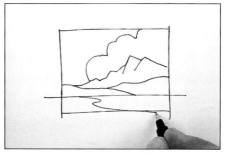

This line, which weaves back to meet our first line, the horizontal, might represent the shore of a lake . . .

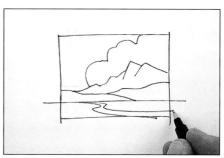

. . . or could be one edge of a road or a river.

64

Trees would move back into this landscape. They enhance the effect because they seem to become smaller as they get further away.

It's amazing what you can achieve in just a few lines.

Vary the composition
The elements of this little landscape can be varied in any number of ways. High horizon . . .

. . . or low horizon. Or shift things around; adding or removing whatever you like.

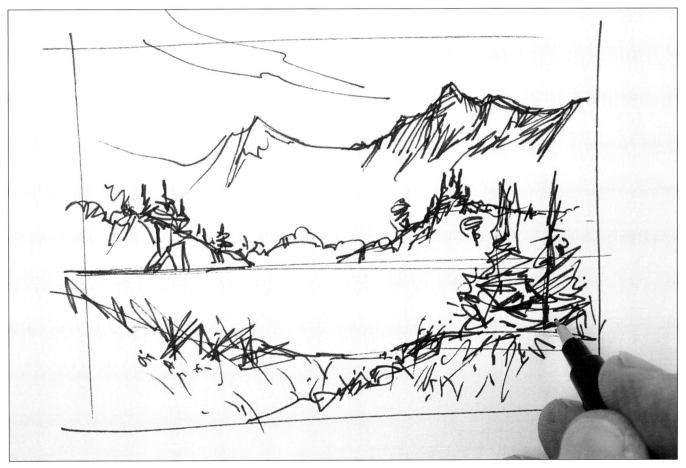

Change your drawing style
Whether drawn as a crisp outline or sketchy, like this, the result is the same: a landscape which you evolved from nothing; and only a beginning to the possibilities.

THREE-LINE SKETCHES

The three-line sketch is my secret weapon. It is the ultimate planning tool for watercolor, helping me to simplify and analyze a landscape on location, and then later when I work out how to incorporate that subject into a finished watercolor. It doesn't have to be "three" lines exactly but it should be very, very simple.

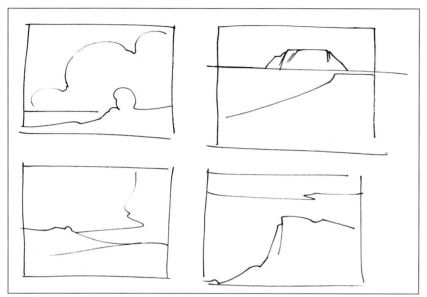

Here are a few examples. In each of them the main elements of a composition are revealed. Later, when I'm painting, these quite often guide me in the first broad brushstrokes that can make or break the composition, especially if I'm working directly and without the benefit of a preliminary sketch (onto the painting surface).

Quick sketches with a brush
Grab a brush and any old paper and try sketching with it! Rough, dry-brush effects have a life of their own and before long you'll find the brushmarks hinting at textures and foliage and who-knows-what! Let the brush explore the landscape and do lots of them. After a while, making up landscapes becomes second nature and so it's no great feat to build up a collection of useful ideas which you can refer to whenever you need a subject!

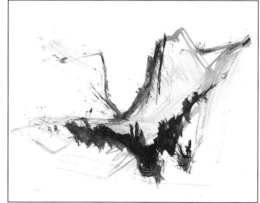

BRING OUT THOSE PAINTS!
These little landscapes are perfect vehicles for color notes in watercolor.

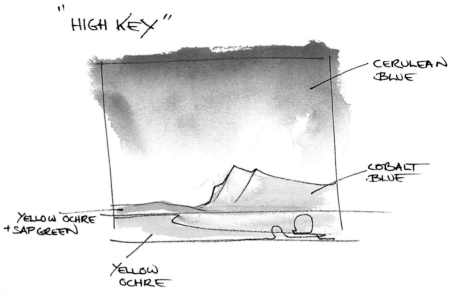

"HIGH KEY"

CERULEAN BLUE

COBALT BLUE

YELLOW OCHRE + SAP GREEN

YELLOW OCHRE

To try out high-key . . .

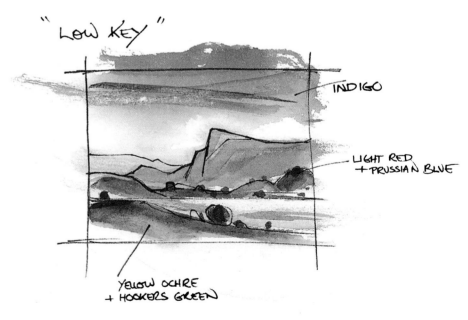

"LOW KEY"

INDIGO

LIGHT RED + PRUSSIAN BLUE

YELLOW OCHRE + HOOKERS GREEN

. . . and low-key possibilities.

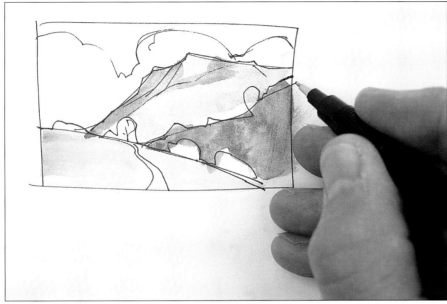

Shadow the mountains

It's a simple matter to build up a shadow wash which runs down the mountains and over the landforms below. If you're unsure about where the shadows should go, then what about building up the shadows areas in pencil first, and then filling them in?

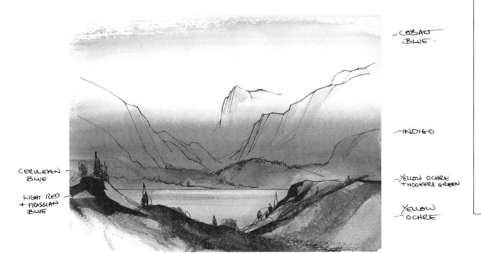

COBALT BLUE.

INDIGO

CERULEAN BLUE

YELLOW OCHRE +HOOKERS GREEN

LIGHT RED + PRUSSIAN BLUE

YELLOW OCHRE

Pen and wash

Spend a little more time on one and you may fall in love with the possibilities of pen and wash.

YOU'VE BEEN CONDITIONED

Let's face it, we've all been "compositionally conditioned" throughout our lives. And, if you've always enjoyed looking at art, especially "Great Art", you've been highly conditioned! Why not use this conditioning to help you create landscape compositions of your own entirely from imagination? Because you've seen so many works you do know what a good picture looks like!

You simply have to access the store of information about composition that you already have (which you've acquired simply by looking at art all your life); and then trust your instincts. It boils down to this: if it looks good, do it! If you sense that a mountain would look good here (or over there) then paint it in. If you'd just love to see a wood down by that lake then go ahead, paint the trees in. There aren't any rules that you have to follow when you paint from imagination. If you want to make use of the Golden Section or any other traditional convention then it's yours. Use it, but also feel free to paint your imaginary landscapes without reference to any conventions. There's a special excitement when a thing looks just right, even if you can't say why its right but just know it. Cultivate that feeling and trust in it!

Confidence is an important element in art: color confidence, creative confidence and COMPOSITIONAL CONFIDENCE!

It takes time to develop but you can start right now. Be your own teacher. Set yourself a few practical (and enjoyable) assignments to train yourself to develop a strong feeling for it.

1. Experiment.
2. Try to identify compositional devices that have been used in other artists' works.
3. Analyze your own work critically.
4. Set yourself small exercises in composition (for example, how many variations on a particular landscape can you design?) Remember, it's better to paint the same scene six different ways than it is to paint six different scenes the same way!
5. Study the way composition is used in other visual arts. For example, use your video pause-button to freeze scenes in movies, or nature programs you admire. Analyze and sketch the compositions that are revealed.
6. Above all, tap into your pre-conditioning — that library of experiences with art and films buried deep within and then allow yourself the right to compose in your own way.

CHAPTER 8: COLOR CONFIDENCE

Great ways to build your creativity and your color confidence

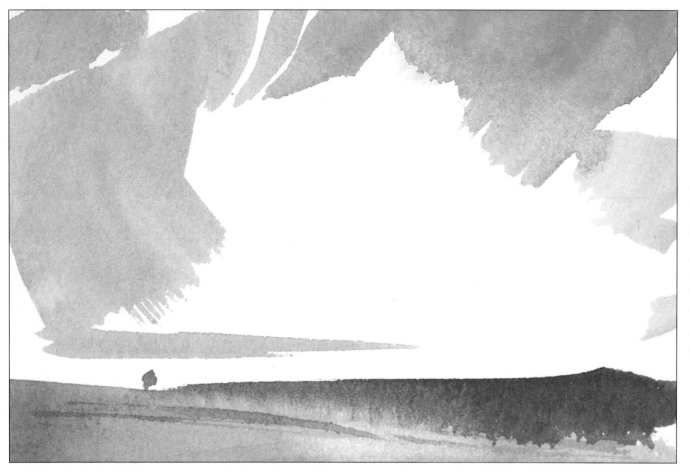

Let's look at confidence a little more closely. In the last chapter I said that an artist really must develop various forms of confidence, including creative confidence, compositional confidence and color confidence. Although these are not recognised artistic terms, they should be. Confidence is one of the fuels that powers the imagination, and imagination is the mainstay of the creative painter.

Once you are confident of your basic skills then you can start to look forward to each new painting for the exciting challenge it presents. Confidence turns nervousness into excitement! One of the things I most enjoy about watercolor is the excitement I feel when faced with the challenge of a new sheet of paper. Once I begin and the washes start flowing, I know that I will need to focus all my concentration on the task in hand. It's a daunting proposition, and that's when you really need confidence in your own ability.

COLOR

Which color is the right color? How often have you wondered this when faced with a subject you'd like to paint? In fact there's no such thing as the right color for a watercolor landscape, unless you bind yourself to slavishly duplicating the exact colors of Nature. Nature does it better and a painted landscape can never equal the real thing.

A landscape in watercolor, whether painted on site outdoors, or totally made up, is your personal product; you can select and mix colors to approximate Nature or you can completely ignore reality. There are principles you will need to know if you want the colors to work with each other, but that's another thing entirely!

Okay, so you do want to be able to select and mix colors that will enable you to approximate Nature? No problem. Here are two ways to learn about color and to develop color confidence.

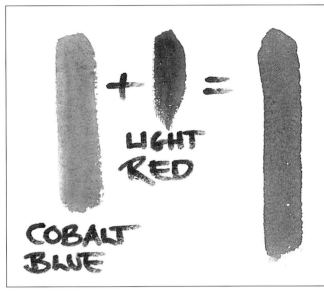

TACTIC 1 — STUDY COLOR MIXING

Colour mixing is a science really (and there are lots of great books available which treat it with the respect it deserves). Learn which colors to mix (and the proportions) and eventually apply the formulas as you need them. It's a bit like learning to cook by recipe and a great way to learn how color can be used.

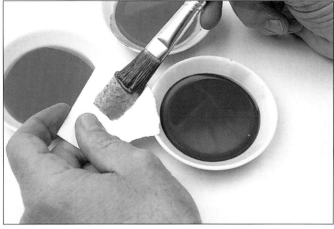

TACTIC 2 — LEARN BY "TASTE"

Start with a few colors at first, using them to paint limited palette landscapes, until you understand how they act and interact when applied. Then, as confidence increases, add more and more colors to your working palette. After a while you will start to guess with some certainty, until eventually you will know which of your paints will approximate a particular color. (It's a bit like asking an experienced chef to identify the ingredients of a dish from taste alone. Very often they can do this and, what's more, they can tell you what to add to lift the flavor further!)

Although art suppliers offer a bewildering array of vibrant colors it is worth remembering that some of the greatest watercolorists use very few colors! Building up your confidence while slowly expanding from a limited palette is a very sound method for developing color competence. And the great thing is that mixing charts are unnecessary once you acquire a taste for color. The decision-making processes for a painting should remain with the artist. When you can rely on experience and intuition to guide you, you set yourself free to experiment. And the truly creative person is empowered by freedom. Your color choices are your own.

PAINT SMALL COLOR NOTES FIRST

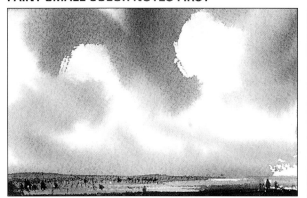

Color notes are fun to paint. Really! They help you to sort out your ideas very quickly. In the "Fold out and Follow" section I'll show how to use small color notes, such as this tiny coastal view, as reference points for more detailed works.

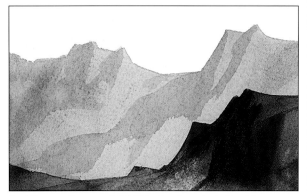

And they really are small! This shadow study (and the previous coastal view) are each only about 3¹⁄₈ x 4³⁄₄". You can paint them on scraps of paper.

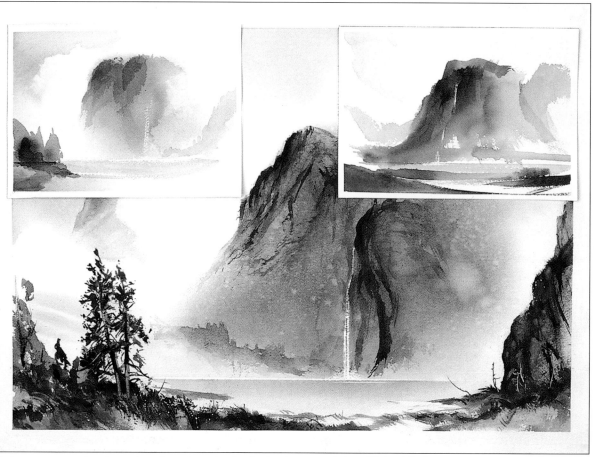

Perhaps you can already see how the color notes for the front cover painting, "Rising Mist", led to the final work. But right now, here are two easy approaches, using dry-brush and wet-in-wet, that you can experiment with straightaway.

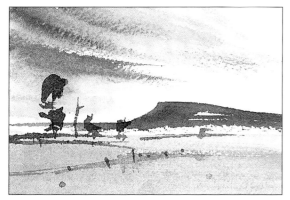

Working dry-brush
Make a few sweeps of Cobalt Blue to create the sky, then a single horizontal sweep in Yellow Ochre to create the land. Next, shape the major landforms (distant hills in this case) using a flat nylon brush and some Indigo. Next come the details: build them up in a suitable color with a few dabs and flicks of a finer brush. Easy! Go on, try!

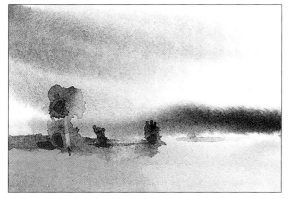

Working wet-in-wet
Having wetted your sheet, build the major tonal areas or color values with a few broad sweeps while it is still wet. Then, as it dries, build up the mass of larger, stronger areas (nearby trees or other objects) with a few deft blobs.

Finally, after it dries lift any light areas such as tree trunks, reflections, sunny patches, and so on, before finishing off with a few crisp details if required (but do remember that a color note is not a finished art work).

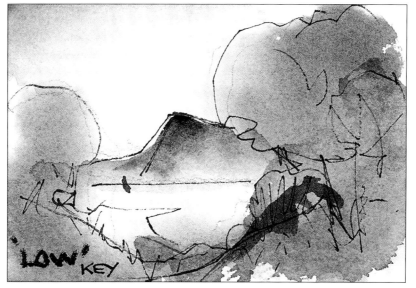

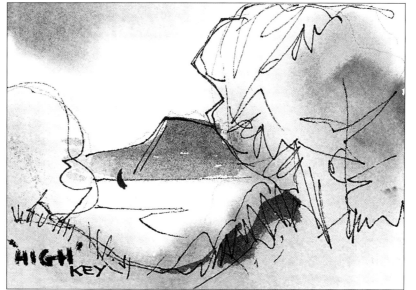

TRY LIMITED PALETTE SKETCHES IN LOW AND HIGH-KEY COLORS

When arrived at by mixing pigment, low key colors seem duller to the eye. That's because they are selected from closer to the center of the artists' color wheel — where colors carry something of all other colors. (Do you remember what happened to my "bright" colours when I mixed them together in a jar of water earlier?) Here's a pen sketch washed with a low-key, limited palette: Yellow Ochre, Indigo and Alizarin Crimson.

Conversely, high-key colors (selected further from the center of the artists' color wheel), almost seem to the eye to be a brighter, purer version of color itself. Here's the same sketch painted using a higher keyed, limited palette: Cadmium Yellow, Cobalt Blue and Cadmium Red.

COLOR SKETCHING FOR COLOR CONFIDENCE

A powerful way to build up your creativity and confidence is to sketch out-of-doors, making color records of the world around. If you want to create original landscapes in watercolor then you will need to develop your ability to see the real world in watercolor terms. You don't need to become an expert, or even paint a single finished landscape from real life, but you should get out there and make sketches from Nature.

Start with a few carefully selected colors; get to know them; and then gradually add more colors, one or two at a time.

Here are two friends of mine sketching late one evening by Ullswater in England's famous Lake District.

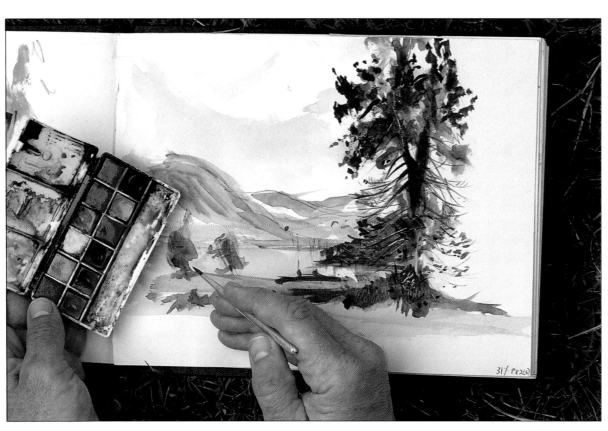

BUILDING UP COLOR CONFIDENCE

Color confidence comes with experience; and experience is gained when you paint and paint and paint! That's why lots of little sketches that succeed are better than one or two grand works that don't.

Think of color as a friend, not an enemy. The opposite of color confidence is probably color fear — and lots of artists really are afraid of color because they've never taken the time to learn how to use it. Don't rush yourself into using too many colors. There's plenty to learn in watercolor without trying to do everything at once. Just managing the washes is always a challenge.

START WITH A FEW CAREFULLY SELECTED COLORS: GET TO KNOW THEM; AND THEN GRADUALLY ADD MORE COLORS, ONE OR TWO AT A TIME.

Not much time and very little light on the scene meant I could only make a couple of quick, low-key studies — one of them into my sketchbook using dry-brush, the other onto watercolor paper, wet-in-wet over a pencil sketch. Though the product of a moment, even now these studies bring that moment back to me — which is the point of sketching!

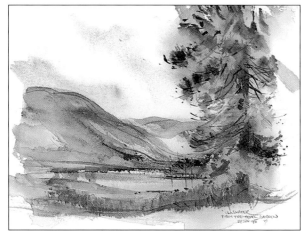

How to paint a simplified pen and wash

Take a look at the watercolor below. How do you think it was painted? The answer is, it was dashed off in a cheap sketchbook, on ordinary cartridge paper, and was the product of a few minutes work. Pen and wash paintings like this are a great confidence builder.

I'm going to show you how to do this; combining pen (or pencil) and wash in the simplest way ever. Let's call this method, "simplified" pen and wash, because the key is to work very simply and quickly.

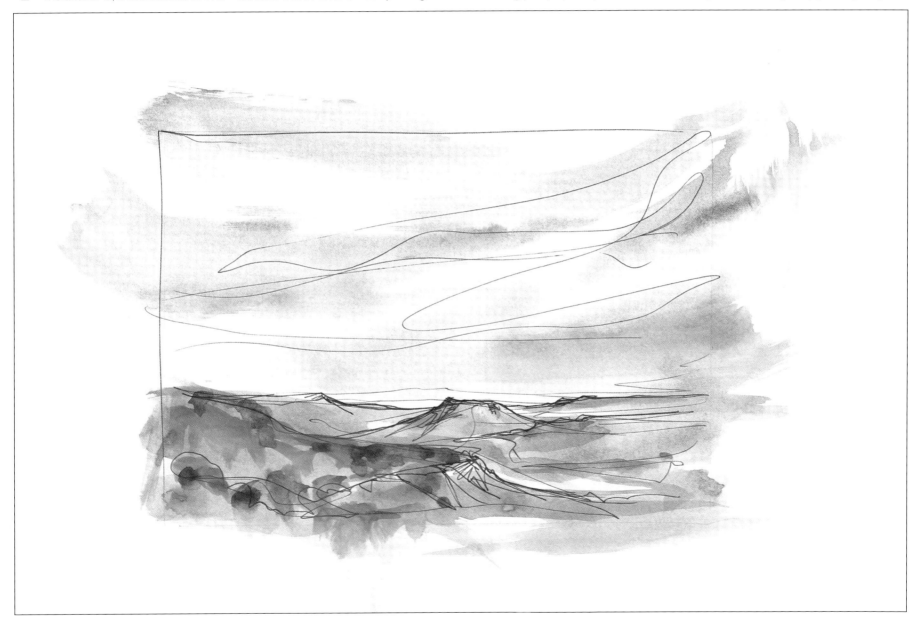

SPEEDY PEN AND WASH

For this exercise simply lay down broad washes over drawing — a simple pen sketch then a few horizontal passes of color — applied wet-in-wet. Use the same colors as for the previous two studies, (Cobalt Blue for the sky, a warm Yellow Ochre/Light Red mix for the nearby land and a sweep of Indigo for the distant mountains).

These washes unify the sketch and "colorize" it (as they might say in the movies). It's actually a simplified historical method reflecting the 17th century when watercolors were known as "stained" or "tinted" drawings. Here goes.

Simple pen sketch
Using a non-soluble ink pen (even a ballpoint pen will do) sketch an imaginary landscape with foreground and distant mountains. Don't fuss with it. Keep this one uncomplicated.

Sky with one brushstroke
Brush clean water over it to prepare for "wet-in-wet". Load a large brush with suitable sky-color (I used Cobalt Blue) and establish the sky with a very direct, broad, horizontal sweep that runs right across the picture. The color is not confined within the details (don't even worry about the edges of the picture!) but provides the general color of the scene. Try to resist the temptation to mess about with it — let the watercolor speak for itself!

Land with one brushstroke
Now rinse your brush and reload with a suitable color (I used Yellow Ochre), and lay down the foreground with a broad horizontal sweep. You could use any color you like because, of course, a green or dark "earth" brown will create very different results. Once again, let the colors flow without fussing with the edges. Relax.

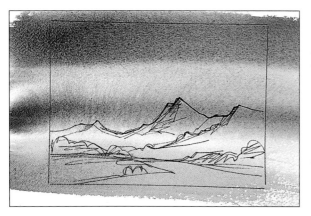

Mountains with one brushstroke
Rinse again and reload with a suitable color, (Indigo was my choice), to lay a broad band across the mountains. Because you're painting from imagination there's no limit to the colors you can use. Different colors over a similar sketch would create a very different effect (in fact it would be a good experiment!)

The aim is to create a colored "atmosphere". I find this a great confidence builder, suggesting lots of other ways to sketch in watercolor, with or without pen-work. It's a great method for both outdoor sketching and working up your imaginary landscapes; for example, if you wanted to experiment with the colors of dawn, or a sunset, or an incoming storm over any type of landscape.

"This is the secret to reducing a big, complicated subject to a simple sketch."

74

THREE-LINE SKETCH AND A FEW COLORS

You may remember that in the previous chapter I described three-line sketching as my "secret weapon", a planning tool that helps me to *simplify* and *analyze* landscape and also to figure out how to incorporate quite complicated subjects into finished watercolors. How do you reduce a big, complicated subject to a simple sketch, and how then, into a watercolor?

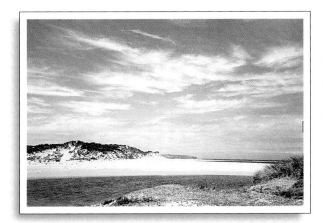

The scene

It was a beautiful day, and we were *en route* to our family vacation at the beach. The family car stopped just long enough for me to snap a photo of the coastline — which was quite spectacular! This is a big view and seems quite complicated at first glance. But it can be simplified. Here's how to reduce it to a three-line pen sketch and three or four strokes of watercolor. What's more, this can all be done in about as much time as it would take you to get out your camera!

Three-line sketch

It's easy! First establish the foreground with one line, the far shore of the inlet with another, and the outline of the dunes with a third.

Sky and water with a few brushstrokes

Now, wet the entire picture and load your brush with a suitable "sky color". I used Cobalt Blue. Create the windswept sky with a few sweeps of the brush. Don't try to create the exact sky — create the idea of the sky (there's a big difference!). Use the same blue to wash in the water. "But it's a different color from the sky" I can hear you saying, and you're right. However, remember that we're NOT TRYING TO COPY NATURE. We're simplifying a big subject.

Two sweeps for the land

Once again, don't worry about the exact color. I loaded with a pale Yellow Ochre then colored the dunes and foreground with a couple of brush sweeps.

Finishing off

Pick up a little green (I used Yellow Ochre, "greened" with a touch of Hooker's Green Dark) and charge the upper area of the dunes and near-foreground. Then pick up a little of a darker color (I used the warmish gray made by mixing Cobalt Blue and Light Red), and charge the green areas to strengthen the form. That's all there is to it! Later, if you decide to work up a larger painting from this you might shift the landforms around quite a bit to establish your composition. (In the sketch for example, I completely ignored the wonderful, thin line of dark blue that the distant ocean creates.) Were I to paint a more ambitious picture, I would still probably lay the major washes in much the same order. This little preliminary sketch has shown me it's possible.

FOR SWEEPING STATEMENTS TRY A BROAD TREATMENT WITH A FEW COLORS

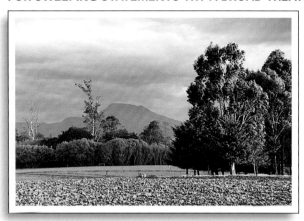

Clearly defined areas of contrasting color
Here is a Tasmanian pastoral scene. The rich warmth of freshly-turned soil contrasts strongly with vivid greens and blues beyond, and over all a covering of cloud broods. Is this a complicated subject? Not really It's not difficult to distil it. Don't be daunted. Simplify, simplify, simplify. Working rapidly.

Thumbnail sketch
For most of these demonstrations I try a test-run on a scrap of paper first, planning each stage before photographing the sequence. You can see the stages numbered here. Out in the field this is exactly how I would work in my sketchbook. And if you're working through this book to teach yourself to paint from the beginning you may find it a useful method for keeping a record of the processes you learned (and of your own experiments) as you go along.

A rapid sketch establishes the major elements
OK, here's the "demonstration". This time, let your pen whizz over the paper. Try to capture the major elements as swiftly as possible. Forget the details. Establish the major shapes.

Two values of one color for trees and sky
Load with a warmish gray made by adding Light Red to Cobalt Blue. Apply it dark and with a few bold strokes to the trees and then pale with a few horizontal sweeps for the sky. Even though these colors are not strictly accurate painting a real scene with the "wrong" colors can be a first step towards total freedom.

One brushstroke for the foreground
Load a broad brush with a medium wash of Burnt Umber. A single sweep is all it takes to paint the ploughed field.

Separate colors for separate elements
You didn't pre-wet the sheet, so at this stage you're still working dry-brush. Establish the "greenery" with one color and the distant mountain with another. (I used the same green again and Cobalt.)

PEN AND COLORED WASH IS A SURE-FIRE WAY TO ESTABLISH TONAL VALUES QUICKLY

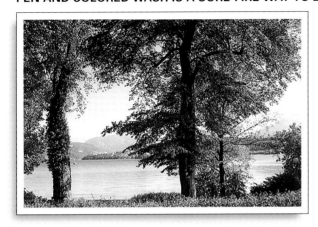

Look at the contrast of light and dark

Here's a lot of green! If you're still worried about painting the exact colors of the original you might be disconcerted by this demonstration, which is all about establishing light and dark — although you could use this approach with any colors. (Where are we? In Switzerland: along the Lake of Lucerne.)

Squint your eyes for a moment and you'll see that this subject is comprised of two strong tonal areas. Viewed through a squint I find that the blue of the lake still reads as blue, while the foreground greenery just reads as "dark".

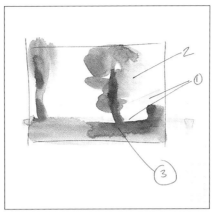

Thumbnail sketch

Once again, here's my little preliminary study. Remember, this was not painted for the book. It's a real "study" and it helped me to confidently proceed to the photo demonstration. In real life, it's about all I would need to plan a quite complex painting, and I might repeat it quite a few times with variations, shifting elements of the composition and experimenting with various washes. You may have noticed: there isn't any pen sketch. I was testing the washes, not the pen work.

Rough pen sketch

This time the sketch is more complicated. But it's not careful pen-drawing! Let your pen scribble furiously — rough pen technique suppresses inhibition! Experiment with tone, building up the dark trunks, foliage and shadows beneath the trees. This is experimental note-taking and very different from creating a finely-rendered drawing. When you've done enough, stop.

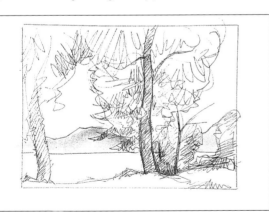

Establish the lighter tones first

In this case, the rear-ground is clearly lighter, and so it's short work to establish the sky, lake and distant shore in tones of blue with a slightly darker tone for the landmass. (I used Cobalt and Cobalt-with-a-touch-of-Indigo to do this.)

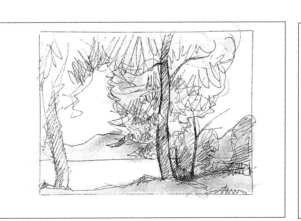

Similarly light tone in a different color

Although I'm not gong to worry about "matching" the exact greens of these specific trees, I do want to establish them as green. I used the Yellow Ochre with Hooker's Green again. This established pale local color (the blues and greens) over virtually the whole picture.

Charge local colors with a darker hue

It's now easy to immediately charge the darker areas with a strong shadow wash. Use a deeper green, or a "shadow" blue — or any color you like. Work quickly, building up the tones and then stop. This "low-key" result might not look very spectacular but, if you squint at this and then back at the original scene, it has established the view, the local color and tonal values. And the real point is that this was all done very simply and quickly.

CHAPTER 9: USING PHOTOGRAPHS CREATIVELY

You CAN use photos — and here's how to do it.

Over the years I've taken what now seems an enormous number of transparencies and prints — and for all sorts of reasons. I really enjoy photography, and happily describe myself as a keen amateur, although in the course of my career I've had many shots published. Like most photographers, when I get my prints or transparencies back from the lab the results are seldom quite as satisfying as I thought they would be. Thinking about this one day, I came to the conclusion that I actually find taking photographs more interesting than looking at them. I suddenly realised that it's the challenge of hunting for better shots that I have really enjoyed all these years.

Nowadays I see my camera as a prime collaborator in my pursuit of landscape ideas for watercolor. Using a camera makes me aware of framing possibilities. It's so easy to experiment with composition in the viewfinder. Most photographs are less important than the lessons I learned on the spot while taking them.

Then why press the shutter at all? Why not save film? Because the resulting photograph is a form of sketch. It doesn't condense, select from, sort out or analyze the scene as well as a sketch would, but it does remind you of the moment when you took the photograph. Just like a photo from a special occasion, like a wedding, reminds you of the moment.

Once you get them into the studio, photographs are a wonderful way to reconstruct your experience — which you so can then begin to work into exploratory sketches, color studies and watercolors. And it doesn't stop there. You can combine elements from different photographs, use photos to add details to an imaginary landscape, distort and manipulate the scenery portrayed, just about anything you like, with the photograph as a creative springboard!

USING THE CAMERA AS A COMPOSITIONAL TOOL

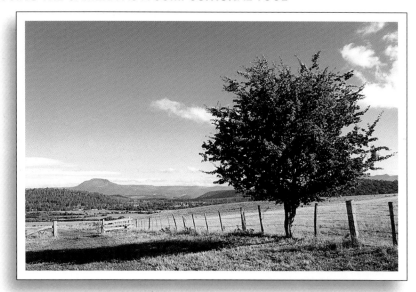

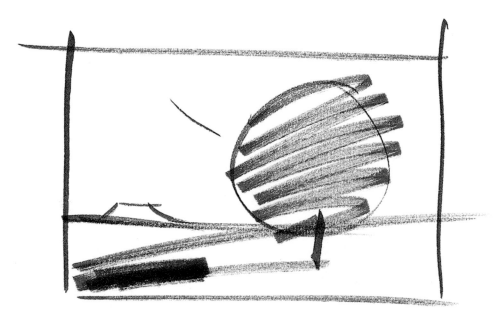

For compositional purposes a camera with a zoom lens (or range of lenses, from wide-angle to zoom) is a wonderful asset. We live on a farm with views towards an unusual landform, Quamby Bluff. Here's a view not far from home recorded with a 28 mm wide-angle lens with the Bluff in the distance. The accompanying thumbnail sketch tells it all.

COMPOSITION SKETCHES FROM PHOTOGRAPHS

Here's another location, also not far from my studio, photographed in a number of different ways with accompanying compositional studies. I used my kids' felt pens to make these very rapidly (maybe 15 seconds each) — a system I recommend because you don't have a chance to be fussy. Don't worry about exact proportions (for example, is the mountain the right size?) but draw very quickly to establish the basic compositional elements. If you can't do it quickly, try another one until you can! In many cases, I think you might agree that the sketches are more exciting than the photos (which were only taken for information after all). But isn't that the way it should be?

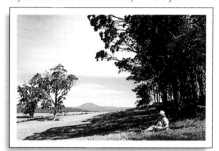

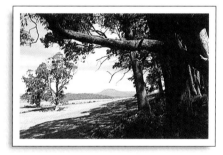

Here's the same view as on the previous page taken with a 110 mm telephoto lens. The tree is still the dominant subject, but now the mountain appears larger. If you move around with your camera you'll find lots of ways to experiment with the possibilities of any subject.

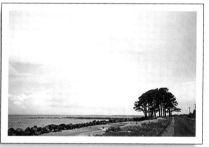

Try to reduce the subject to its bare essentials.

When taking the photo I positioned the entrance to this forest according to the Golden Section, then placed the figure in silhouette.

Here's a well known landmark, Sydney Harbour Bridge. Although it's tempting to see it as a very complex subject, it is in fact a very simple one in compositional terms.

SKETCHING FROM PHOTOS USING A FEW LINES

I usually find a few lines are sufficient to reconstruct the vital spatial elements of sky and land as I remember them, with the photo as my assistant rather than my guide.

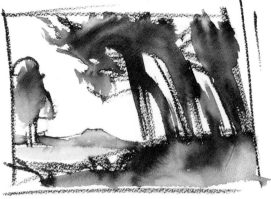
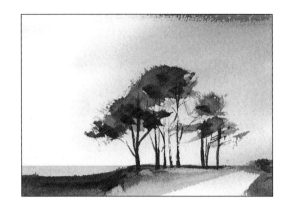

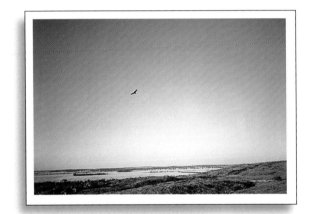

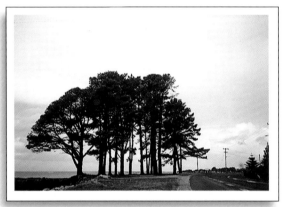

Rapid color notes from photographs are sometimes a very useful guide to wash strength and always enable me to visualize my subject in terms of watercolor.

Early one morning an eagle circled our small group at work on a desert escarpment. I snapped this view with my pocket camera to capture the moment — although it certainly doesn't do that! I later sketched it to show a group of students how easy it is to grab a subject in moments with a quick sketch and color note. Having established the scene with a few pen lines I made three horizontal passes with a hake brush loaded in first Cobalt Blue, then Yellow Ochre and finally, Light Red. A detailed painting with better established proportions and details could later be painted without very much more trouble.

There are lots of ways of doing this. Here's another view from the trees towards Quamby Bluff sketched very quickly using a felt pen, then painted with a few strokes of a broad brush loaded with Yellow Ochre (which wetted the pen causing it to bleed a color not unlike Payne's Gray and so create the green). Sketches like these are fun, and very useful.

And here's a slightly more detailed study based on the trees in a photo. I simplified both the trees and their location. The photo is only a guide.

And here's that study again during a planning stage of one of my paintings.

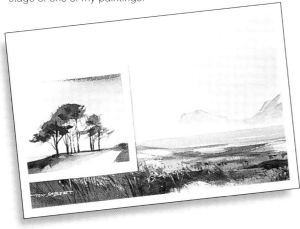

USING PHOTOGRAPHS TO ADD DETAILS TO A LANDSCAPE

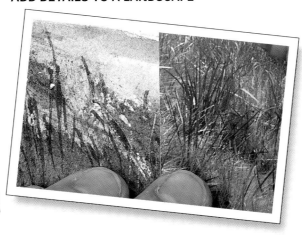

Place a photo of grass next to a detail from a watercolor and you'll see how this works.

BUILDING UP YOUR OWN PHOTO REFERENCE LIBRARY

You've probably got lots of photos at home that don't please aesthetically but do contain good source material for watercolors. Don't throw them away but sort them and file them for reference. Who knows when a photo might provide you with just the kick-start you need! In the next chapter you'll find a few from my own collection to start you off.

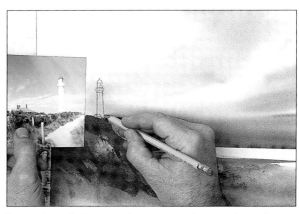

Over the years I've built up a collection of useful photographs of trees, grasses, interesting land formations, mountains, skies, figures (mostly out in the landscape) and so on, which I use for studio work. Along with my sketches and color notes they are among my most useful resource materials. Here, I'm using a photo of coastal grasses (top right) to add details to a painting.

The subject of this coastal scene was always going to be a lighthouse. Where should it go? Over here, or over there? I used a photo of a lighthouse from a completely different location to position it before sketching (with the photo as a guide) and painting it in.

CHAPTER 10: CREATIVE PHOTO REFERENCE LIBRARY

In the "Fold Out and Follow Me" section you'll see me using photos to experiment with composition and the possible placement of trees and all sorts of things.

Just to help you with your own paintings here are a few reference photos, some of which you'll see me using — full size so that you can use them too. They're not great photos, mostly snaps to help me record details of foliage or the way that clouds were building up, or something. I hope that you'll enjoy them and feel inspired to start a collection of your own. It's easy! These photos were not taken to show to other people (let alone publish!) but for my own reference. I hope they illustrate that you only need to have basic camera skills to note-take with a camera, and that you will find these examples useful.

Photo: Ian Bell

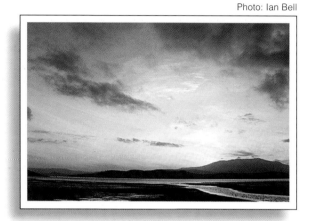

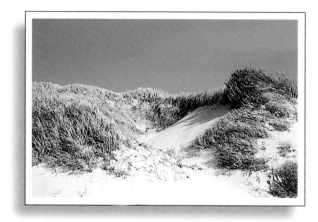

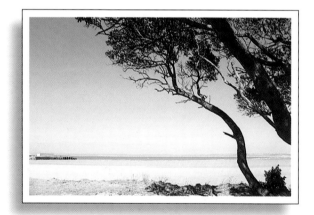

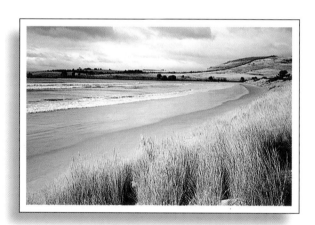

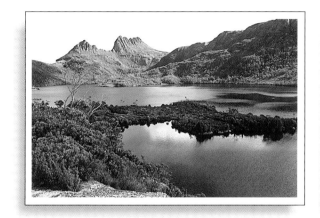

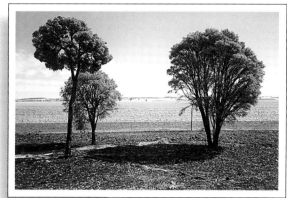

PART III: IDEA STARTERS

KICK-START YOUR IMAGINATION

Making landscapes from "blots".

Contriving big landscapes from little rocks.

Table landscapes from crumpled paper.

Painted miniature landscapes.

Using real branches and twigs.

Creative sketching.

Using dynamic brushwork to create dramatic setting.

How wet-in-wet granulation can create landscape details.

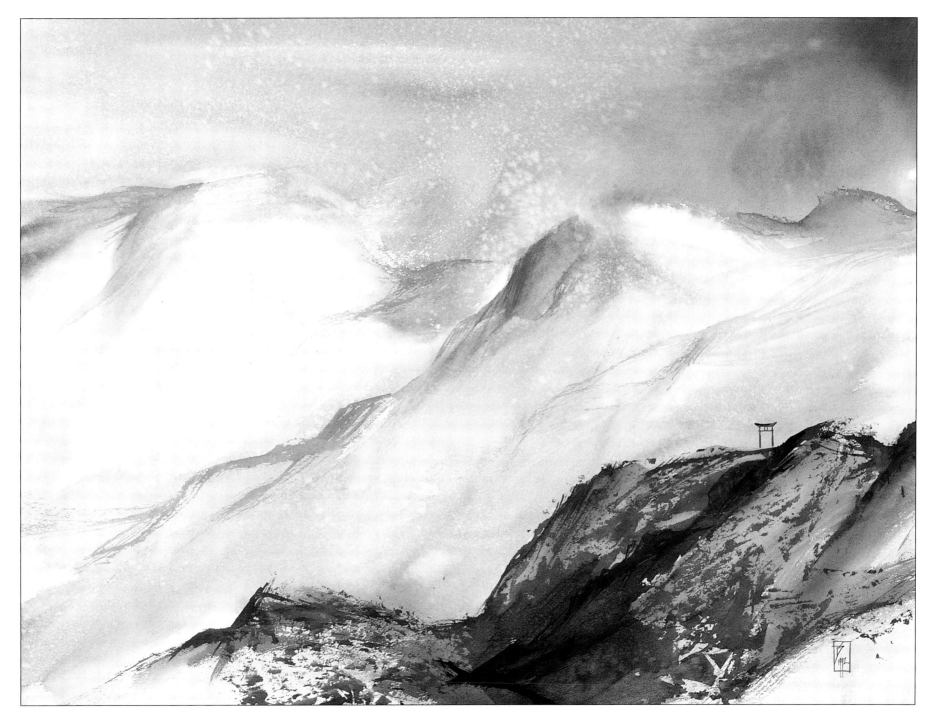

"Nature Spirit" Watercolor 21.3 x 29.1" (540mm x 740mm)

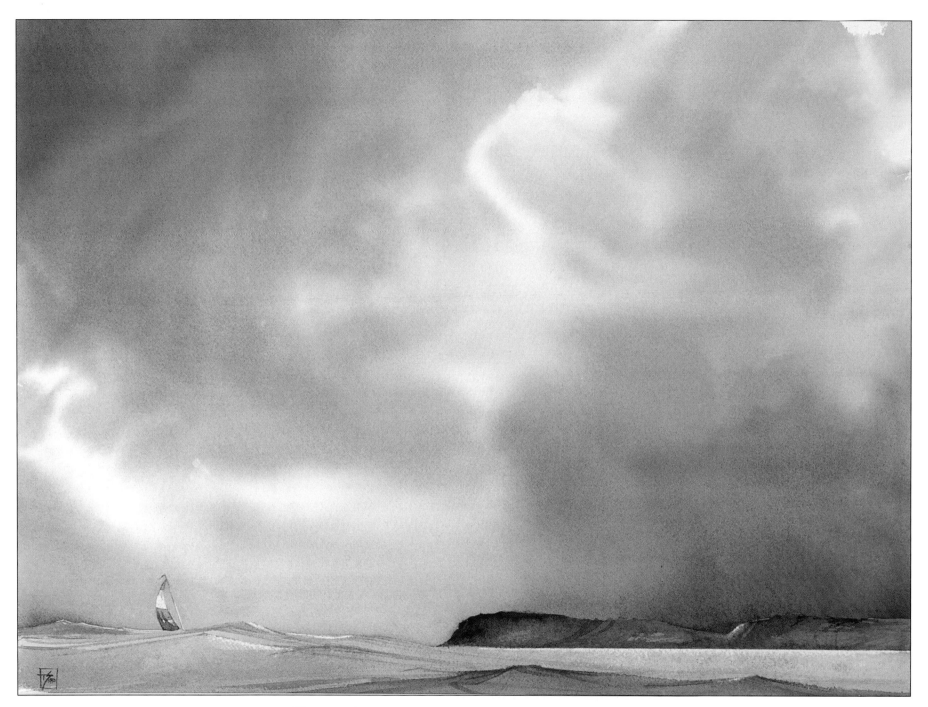

"Harmony of All Things" Watercolor 10.2 x 14.1" (260mm x 360mm)

CHAPTER 11: IDEA STARTERS

The urge to paint may be strong but the biggest obstacle seems to be thinking of a subject to paint.

How to kick-start the creative process

What will I paint? This is a question that plagues many aspiring artists. Even though this beautiful planet inspires grand themes in art, especially in watercolor, and though you may long to express your own unique response to nature and the environment, it's not always easy to do.

This chapter has been designed to help you to further develop your creativity and to show you how to work with watercolor, thinking of it as your companion in the creative process, rather than as a servant. The exercises will show you how to let watercolor stimulate your own ideas as you go along.

The first thing to recognize is that you'll need to let your imagination fire up in its own way — for it won't always create on demand. Watercolor is a voyage of discovery and, as corny as it may sound, the most satisfactory

results are often achieved by taking what comes — not only in terms of painting technique, but also in terms of your individual creative energy.

Over the years I've discovered that my creative preparation for watercolor is not limited to preparatory sketching. Neither is it limited to the period before I start painting. The natural ebb and flow of the processes involved invite me to view the whole production of a watercolor painting as one long creative process. Consequently, an experimental wash may at any time evolve into a mountain landscape or an ocean wave. A series of random splodges with a brush in a half-finished landscape may suddenly suggest a rock face, and the whole painting will suddenly take on a life of its own. Before I begin, a period of playing with shapes and lines, stampings, splodges, and who-knows-what, always

holds the promise of launching me into a completely new landscape project.

Ideas for creating your own vision of nature are all around you. They say that all our life's experiences are stored deep in the memory, which means that every sunset, every mist and snowfall, or forest walk or hike that we have ever experienced is in some vast inner library. If only we could access it. Perhaps we do, but in the wrong way. For example, that tree you painted yesterday and dismissed as clumsy, how did you know it looked wrong? Who told you? You did! You used your inner library with its stored memories of a lifetime of trees to give you that information.

I can't tell you how to access this reference system on demand, but I do know that it seems to work very well, and quite unconsciously when we relax about the creative process.

The human brain is capable of making wonderful associations between what it sees today and what it saw yesterday. For example, in the shape of a tiny rock you may sense the essence of a mighty mountain — and a major work may come from this single association.

Leonardo da Vinci said that he could imagine fantastic landscapes in the random patterns on old walls, while children around the world have always found fantasy formations in the shapes of clouds. There's nothing new here. This chapter is about stimulating and encouraging your imagination to create images without the hindrance of having to refer to an actual view all the time.

Let's structure a few approaches to the "inner library" with a selection of idea starters which should help you invent many more of your own.

What do you see in this random pattern?

A couple of brush strokes to define it a bit, and one or two flicks of the brush for birds turns it into a windswept knoll. A classic idea starter!

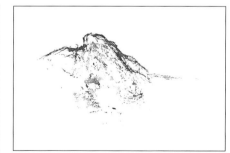

A simple wash turns it into a watercolor.

Original landscapes from random blots

Over 200 years ago a controversial British watercolorist, Alexander Cozens, suggested a new approach. He argued that artists could use ink stampings from crumpled paper to help them to create original landscapes. In a century where watercolor was popularly used to tint topographical drawings, this was a revolutionary notion, and earned Cozens the derogatory nickname, the "Blotmaster".

But he was also known as "Master of the Master", because his son and student, J.R. Cozens, took this new freedom much further and became an important influence in watercolor, particularly on two of the greatest watercolorists of the next generation: Tom Girtin and J.M.W. Turner. But that's another story.

Alexander Cozens' system was a very good one. Any artist can adapt his idea to create imaginary landscapes quite easily. The trick is to select and them manipulate the materials you make your "blots" with so that a sense of "landscape" is constructed from the beginning. But don't let "reality" limit you too much; this system should help you create total fantasies or realistic landscapes. The choice is yours, and it places a world of creative options at your fingertips.

Here's one of the many ways you can go about it, using crumpled plastic as a means of creating the "blot", and then using the blot to create a complete landscape watercolor from your imagination.

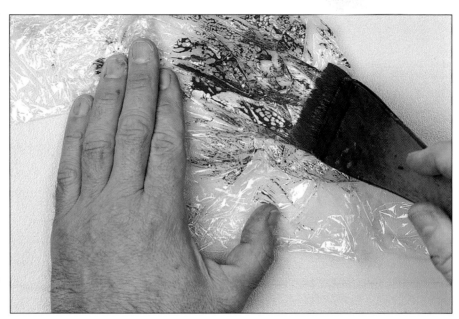

Ordinary kitchen plastic wrap is perfect for this exercise. Crumple and then partly unfold the plastic before applying a light coating of watercolor to it. A dark color mixed to the consistency of a thin paste may give you the best result in your early experiments. You won't have to mix up a lot of it because you're only trying to print the folds in the plastic — like a fingerprint! You'll soon figure out how to achieve just the type of effect you want by varying how much paint you apply.

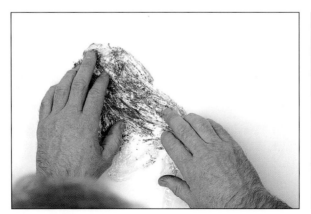

Lay the plastic out, face down, onto your watercolor paper. Then press it down gently to make the first blot. The quality of the blot will depend on the amounts of paint and pressure that you've applied.

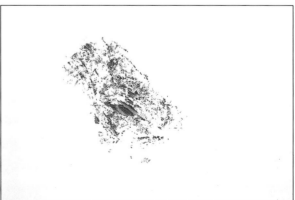

Interesting isn't it? This one suggests the texture of rock.

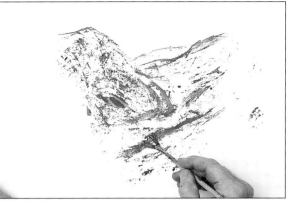

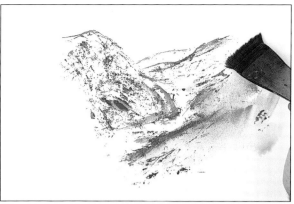

There may be no need to apply more paint to the plastic. There is often enough left on it to make a slightly fainter stamping which is great for suggesting a distant landform. This time alter the shape of the plastic to suggest a distant landform. With the third printing, create a foreground slope. This offers lots of possibilities.

Using a split-brush, define the outer edges of the various landforms. It's easy once you start to believe in the little scene which is emerging.

After this has dried, apply transparent washes over the landforms to create a striking effect.

Working "dry-brush", use your hake to create the effect of rapids tumbling through the areas of reserved white.

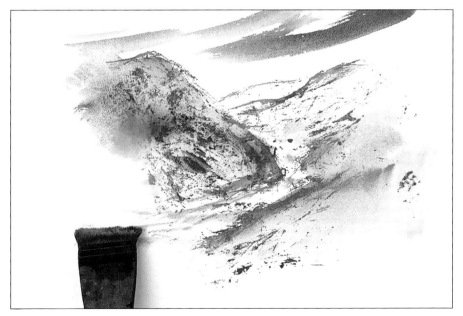

Finish by darkening the rocky outcrop at the bend in the stream.

This easy and exciting way to paint results in a finished landscape. And all from a few blots!

Using rocks to suggest mountains

I've traveled to Japan many times and along the way developed a great affection for Japanese gardens. Not the grand, parklike gardens with lakes and pools and bridges and waterfalls, instead I've always loved the dry landscape gardens, of the Zen temples. In these tiny gardens a small rock in a raked area of sand may represent a mighty mountain in a vast ocean which, in its simplicity, encapsulates the essence of all mountains.

Over the years I have also developed a great liking for the tiny tray landscapes called *bon-seki,* which miniaturize the theme even further, and it became a natural consequence of my travels that I started to improvise little tray landscapes at home to display interesting rocks that reminded me of mountains. Nowadays I use these rocks to experiment with compositions to give me the play of light and texture of much larger landforms. I often sketch directly from the rocks, working in pencil on any scrap of paper or directly into my notebook.

What do you see here? This rock is part of a famous Japanese art work, the zen garden at Ryoanji. Is it just a lump of rock, or does it represent an island in a vast ocean beyond which other islands can be seen? Or is it a peak among others that breaks through clouds over a shrouded valley?

It may simply be an abstract statement in rock and gravel, or it may be a literal interpretation of an ancient ink painting. The "landscape" at Ryoanji could be any of these, or it may carry some deeper philosophical meaning.

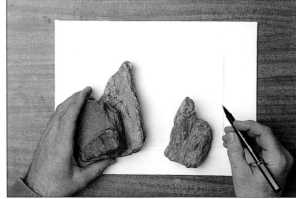

Tape a sheet of paper to a board, then lay out a few rocks into a pleasing composition that suggests a landscape to you.

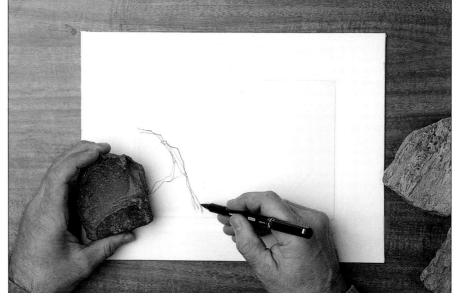

Start with the front rock, sketch it with a fine black pen filled with WATERPROOF ink.

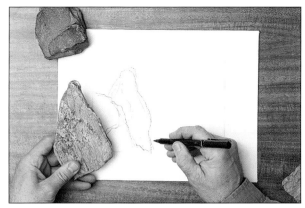

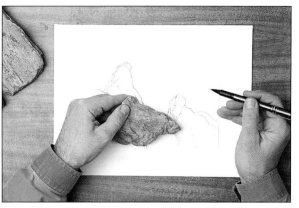

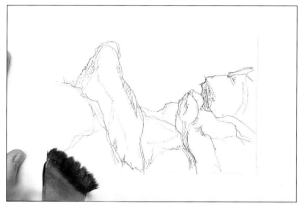

Next, sketch the rock behind it, and try not to be too slavish. These rock shapes are not sacrosanct, they're only idea starters. Then sketch the rock on the right.

After you've done that, refer to your rock collection again and consider the placement of horizontal rock forms for the foreground slopes. Place a distant mountain range too.

Work over the composition, playing with the ink drawing. Shade, strengthen and modify your drawing.

The next step is to wash the whole sheet with clear water because we'll be working wet-in-wet.

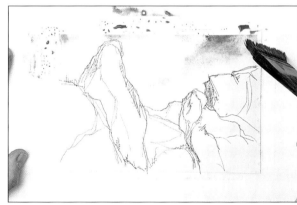

Wash in the sky using a broad brush. This will not be a fussy painting and there will be time to add a few details later.

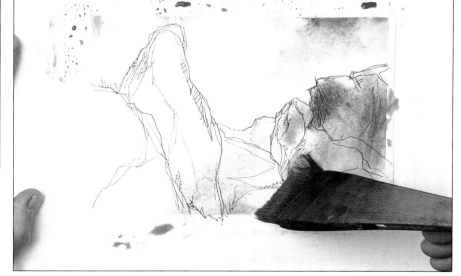

Working quickly add the various colors required to create the entire landscape. See how the shaded ink underdrawing gives the illusion of tone.

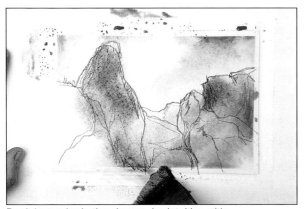

Don't just color in the shapes, be intuitive with your application.

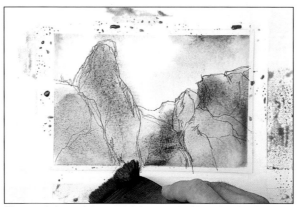

The result is a mighty precipice overlooking the shadowed hollow of the valley below. A dark mountain will obviously contrast with the warmth to the right and particularly with the whiteness of the clouds.

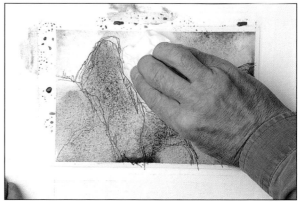

As the wash dries, crisp up the edges of the mountain on the left by using a tissue to lift the wet colour that has bled into the white cloud behind. Don't clean up all the "bleeding" color though.

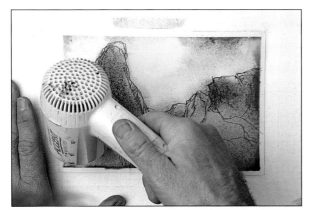

Use your hairdryer to dry the entire picture for the next stage. Your colors will have dried much lighter.

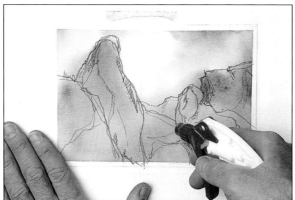

Now it's time to texture it up. Spray with a fine atomiser — you don't want rivulets of water, just a fine mist.

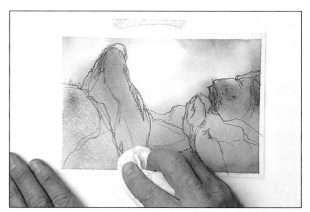

While the surface is wet, blot with a tissue to lift some color off and the result will be a granite, weathered texture.

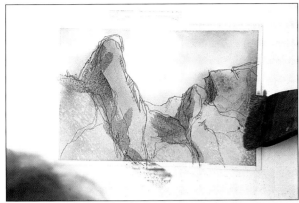

It's time to add some depth. Do this by glazing the shadow areas with Cerulean Blue.

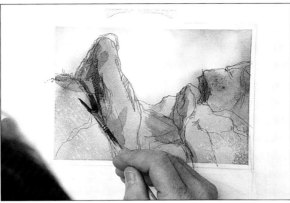

Define the mountains by using the split brush to suggest crevice lines.

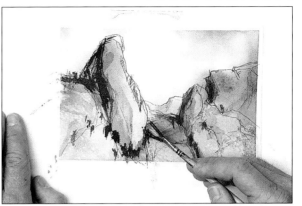

This is a low key work, so paint to please yourself and you will find the landscape becoming more believable and satisfactory as you go along. You may find, like me, that when things get out of hand and every brushmark risks the success of the work that you will come to view this as an important part of the experimental creative process which will teach you to paint not well — but better!

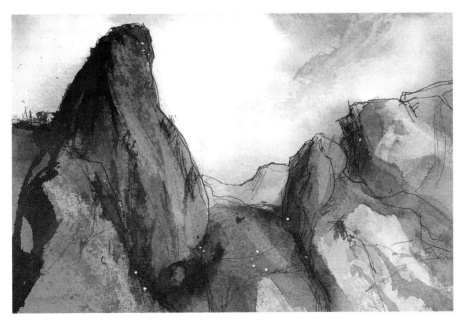

When the painting is dry, pick out a few crisp spots of white with your utility knife as I have done here.

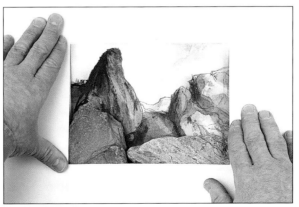

How precisely does your finished work relate to the original rocks? Who cares? I found it amusing to put my inspirational rocks together under a simple mat.

Creating original landscapes from crumpled paper

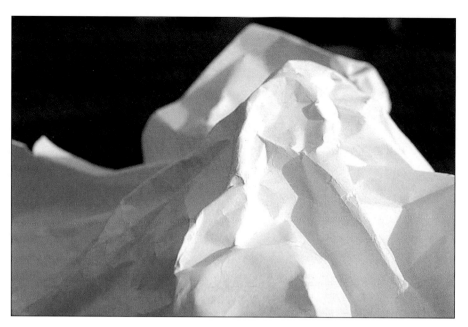

Have you ever wished you could look out your window towards a mountain range? Or that the mountains in your part of the country were a little more rugged?

Then, when you settle down to painting do you wish that you could climb to the edge of a great cliff and look out over a river valley far below?

There are a number of very simple, yet amazingly effective ways in which you can create effective landscapes in miniature inside your studio that will enable you to sketch and paint as if you were perched on that cliff. What's more,

if you'd like the view to offer more or less of the valley, you can shift the mountains around a bit. It's easy, and the materials are probably beside you right now.

Creating studio landscapes in 3D is the easy part. Making use of them requires a little more effort. But it's fun and you're in good company, because lots of other artists throughout history have contrived their own variations on the theme.

I'll show you the simplest one of all first, using crumpled paper. Then I'll suggest ways of taking the idea further, so that you can extend the illusion you have created.

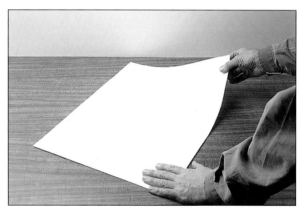

Take a sheet of plain paper and crumple it up into a believable landscape.

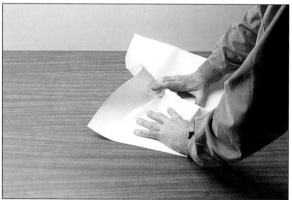

Tap that "inner library" and let your imagination go.

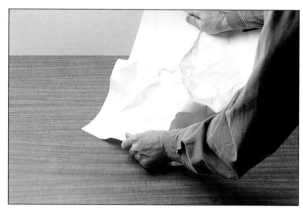

Create soaring peaks, ridge upon ridge of desert ranges — or even a vast flood-plain rising to distant hills.

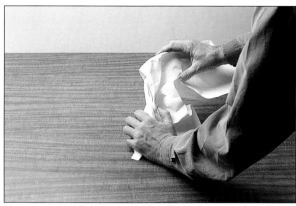

There's no limit to the possibilities. Be ruthless and daring.

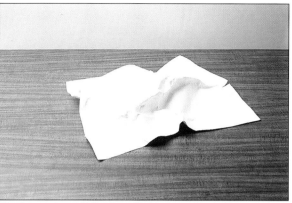

The fun and creativity doesn't stop here. Study the way the light plays across your paper peaks, casting long shadows into the valleys and over the faces of nearby cliffs.

For the fun of it, paint a watercolor sky and set your paper mountains in front of it.

Take your landscape outside in to the sun and see how it looks against the real sky.

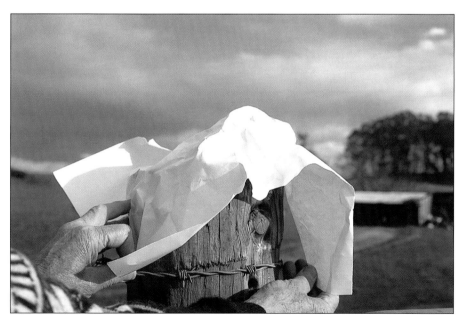

Try moving the landscape about indoors using a single studio lamp to enhance contrast, then make some pencil studies and work directly into watercolor.

Painting your crumpled paper landscapes

Not only have the Japanese been making an art of tray landscapes for centuries, but I remember reading how Thomas Gainsborough used to make little table landscapes with forest of broccoli. We are merely following that tradition with the crumpled paper landscapes. To heighten the illusion you've created with paper landscapes, you can paint them.

Once you start to sketch and paint one of these "table landscapes" it's a great idea to work from lots of different directions, varying your view of it so that you consider all the creative and compositional possibilities at hand. If you haven't done this before I suggest that you "crumple" yourself down this time so that you look out across the landscape exactly as if you were down there standing on it. (Or pick it up and look across it that way.) Try turning it around. Move it around under the lights, so that the shadows play across the surface. It's up to you and your imagination to make it truly come to life. Once it does, get out those pencils, pens and paints!

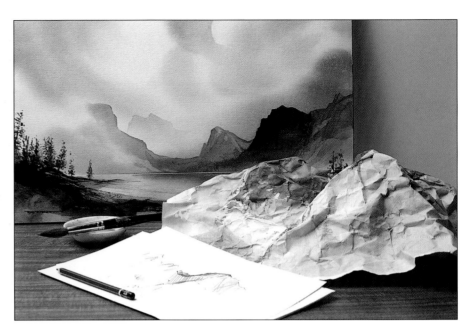

Lay out several bowls of paint. Choose your colors according to the type of topography you want to simulate. Think about the colors in the snow country, or desert heights or peaks with trees below the snowline. Take a sheet of cheap cartridge paper and wet this down thoroghly.

Leave white spaces and vary the direction of your brush.

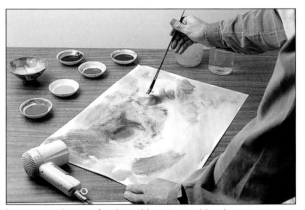

Lay your colors on freely — it's not a real landscape, only something to work from.

96

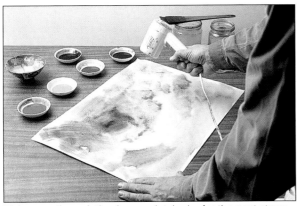

Make sure the painting is completely dry for the next stage.

Crumple it up and let your imagination have free reign.

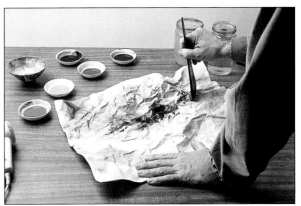

You'll find ideas suggesting themselves to you. Go along with them. Uncrumple the paper and add shadows and dark rocky areas.

The shapes can be changed again and again.

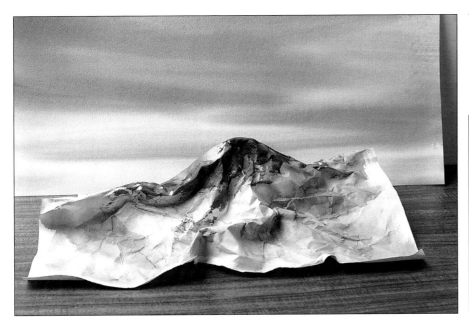

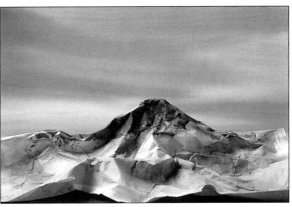

A painted sky backdrop heightens the illusion.

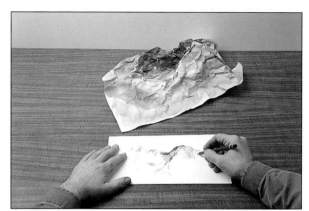

Make some quick sketches of your imaginary mountain range.

We can call on one of John Constable's ideas to give the effect of clouds passing overhead. He used to crumple up a handkerchief to study the way light filters through clouds. Here a sheet of dark paper obscures the studio lights, creating intense shadow and the brooding presence of a distant peak under low, dark clouds.

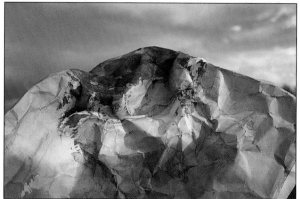

Paint in the shadow and then take your paper landscape out and hold it up against a real sky.

Look at these highlights and contrasts. Does this suggest a mysterious, dark, dangerous mountain to you?

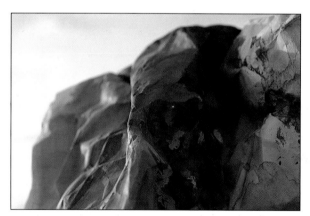

And we've done all this with paper!

Combining photos and real twigs

Do you ever use your camera as an aid to composition, taking dozens of photos that your family and friends consider a waste of film? You know the ones, those empty landscapes with the sky occupying a little more space in this shot and a little less in the next. When you study these photographs do you ever wish they contained "something in the foreground" — that classic tree cutting across the composition, or even a few branches coming from the left and adding interest to an empty sky? Why not add them yourself?

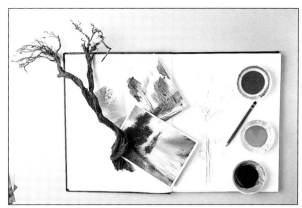

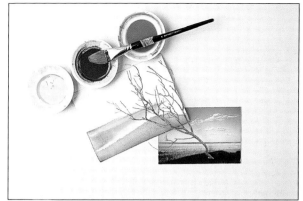

Here's how I used a scene photo and a found twig to suggest this desert landscape — and I only used three colors.

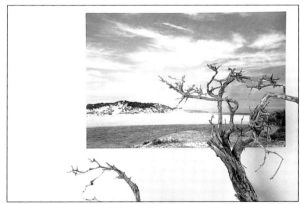

This coastal view became a different idea starter every time a different "tree" was added.

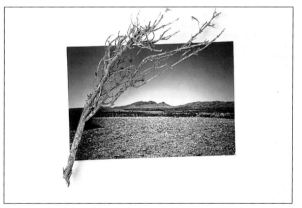

You can use your "trees" to enhance your composition with strong diagonals and verticals. Use them over and again by rotating them to get a different effect.

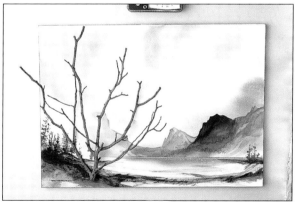

Your stick collection will come in handy when you've working on a painting and want to add a tree in the foreground. I have quite large branches that I use frequently.

PART IV: THE PROJECTS

"RISING MIST"

A complete project designed to help you use your imagination skills.

"RIDING THE WIND"

A second project containing information on colors, sketches, washes and special brushes, so you can create your own imaginary landscape.

"EVENING LIGHT"

The creative processes shown here will bring your skill and confidence to a new level.

How to use the "Fold Out and Follow Me" guide inside the back cover

All the exercises contained in the front section of this book have been specially structured to show you not only how to build up your repertoire of painting skills, but to get your creative juices flowing.

Now it's time to put what you've learned into practice, and along the way develop your imagination skills even further.

To help you create your own original landscapes there's a special "Fold Out and Follow Me" guide which puts the reference painting in front of you all the time as you work.

Now you can follow every step in the stages of progression of each challenging project, and enjoy the unique benefit of having the major painting in front of you for every brushstroke along the way.

Just select the project you want to work on, fold out the finished painting in the back of the book and not only will you be able to see where you are in the process, but where you are going too!

1 Choose your project
Look for the reproduction of the relevant project on the fold out page inside the back cover of this book. Each project is named with the title of the painting.

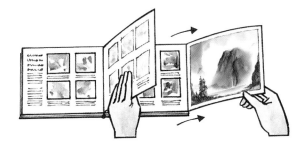

2 Fold out the finished painting
Carefully fold out the page so you are able to view the finished painting while turning pages of the chapter.

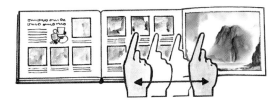

3 Follow the stages to recreate the project
As you follow the step-by-step project, you can instantly refer to the folded out painting to see what stage you are at, what to do, and what comes next.

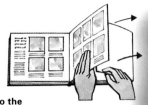

1. **Go to the "Fold Out and Follow Me" guide in the back of the book**
Look for the reproduction of "Rising Mist" on the fold out page inside the back cover.

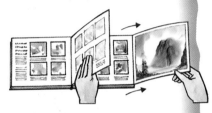

2. **Fold out the finished painting**
Carefully fold out the page so you are able to view the finished painting while turning pages of this chapter.

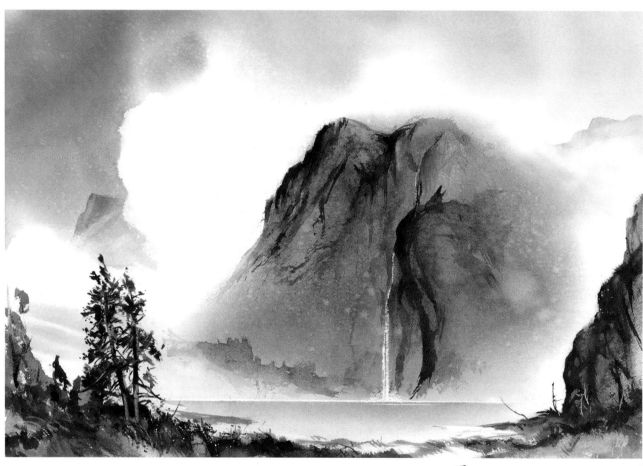

"Rising Mist" Watercolor 18¹/₂" x 12¹/₂" (473 mm x 322 mm)

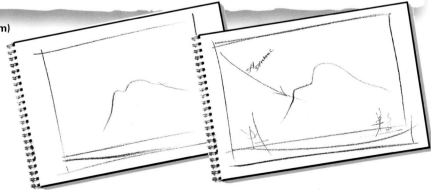

A complete project designed to help you use your imagination skills.
Here's where you put into practice what you've learned previously.

PROJECT 1

How to recreate "Rising Mist" landscape project

3. **Follow the stages to recreate this landscape project**

As you follow this step-by-step project, you can instantly refer to the folded out painting to see what stage you are at, what to do, and what comes next.

If you've been working along with me now you're ready to put watercolor to work for yourself and will be itching to create your own original landscapes.

Let's call on the techniques you've learned in the front sections of this book, combine them into one landscape, and along the way explore how they can work together.

I'm going to demonstrate the processes involved in painting "Rising Mist" which you'll find in the "Fold Out and Follow Me" section at the back of this book. Simply fold out the reproduction of this painting and follow the process step-by-step.

These "Fold Out and Follow Me" paintings give us a chance to work along together. They show you the technical and creative processes involved, but the end result will be your own version of this original landscape.

You may find yourself halfway through my suggestions and decide that you like what you've achieved right there; and that the painting is complete. If that happens, why not stop, put what you've done to one side as a success and try another variation of the theme?

Each picture will look different from mine, and will take on a life of its own, for many reasons. Washes, in particular, often do their own thing, closing the door on various creative options, but also opening them to others. Your photo and rock collections will certainly be different from mine. All sorts of factors will affect the way your paintings evolve.

I suggest you view this project as a creative exploration that ties together interesting techniques and stimulates your imagination so you can develop your own ideas.

In the case of "Rising Mist"

I recommend that you try the painting a few times, so that your creative options become clearer to you each time and, believe me, there are options at every stage, starting with the three-line sketches.

If you stick to the basic theme, then hopefully, as you reach each stage in the evolution of your own paintings, you'll find me right there with further suggestions to assist you. Good luck!

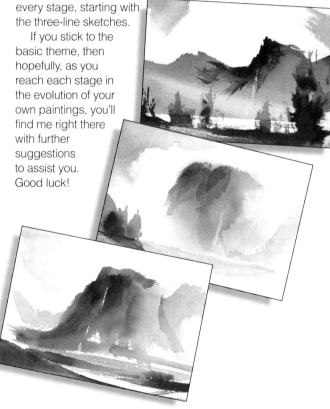

103

Three-line sketches

The essence of a composition can often be reduced to a few simple lines. Three-line sketches make it possible for you to clarify your ideas before you begin. When used to establish the basic composition, direction of brushstrokes and tonal structure, the three-line system is a powerful tool at your command. Vary the number of lines as you like — it's the idea of the system that counts, not the number of lines!

A series of three-line sketches establishes the possible locations of the main elements.

The basic dynamics of the sky will be set.

The prominent landform, your lead actor in this drama, will be established.

A very simple sketch establishes the tonal values and shows how central drama of lake and waterfall will be framed within the composition.

The palette

You'll need to have all your colors ready to go.

Prepare six dishes of the following colors: Yellow Ochre, Cobalt Blue, Cerulean Blue, Hooker's Green, Lamp Black. The last dish will contain your gray made from Phthalo Blue and Light Red.

Just preparing the individual colors is not enough, the trick is to keep them in suspension for when you need them by stirring them up again just before you begin.

This becomes second nature after a while.

By working with a relatively limited palette at first you'll lessen the task of preparing washes. You'll also find it easier to ensure that the colors you do use work harmoniously together.

| YELLOW OCHRE | COBALT BLUE | CERULEAN BLUE | HOOKER'S GREEN DARK | LAMP BLACK | A little PHTHALO BLUE | Added to | More of LIGHT RED | Makes | Variations of this gray |
| Grass area | Sky and lake, and shadows on the mountain | Unifying blue | Areas of foliage | Foliage and rock details | | | | = | |

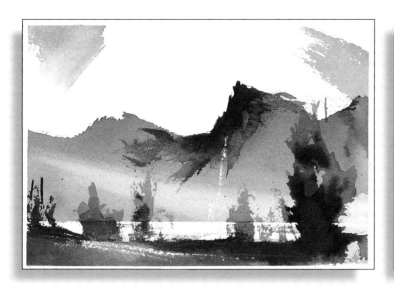

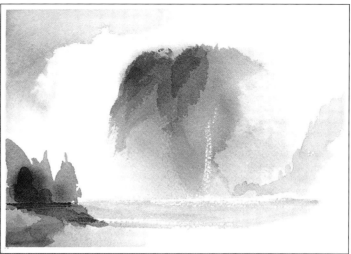

To find out where you are, what to aim for, and what comes next, refer to the reproduction of **RISING MIST** in the **"Fold Out and Follow Me"** guide inside the back cover of this book!

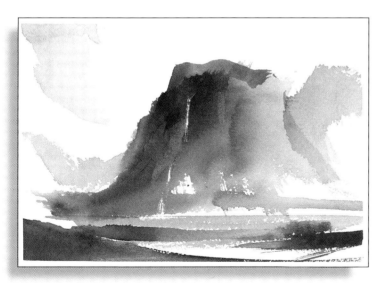

The color notes

Color notes are another way of planning before you begin. Nobody likes to start a large painting then realise that it's going badly because of lack of planning. Small and informal studies are a traditional way to prepare for a major work. Here are some of my own from the development of "Rising Mist". There's nothing formal about them. They were dashed down with a big brush on scraps of paper so that I could identify the way that areas of color and tone would interrelate. Think of your own color notes as experiments. There's no need to copy mine but do consider the role of the major elements in your composition and extend your thoughts beyond the three-line sketches. Two or three studies will certainly help you to establish the color values and a working color harmony to sustain throughout the final work. They will also make it easier to successfully establish the basic composition with the very first washes.

It should be apparent, even on a small scale, which ones work well. I've selected one which will help me to show you the impact of each element as it is added throughout the evolution of the final painting.

The important role of visualization

Try to imagine the sort of thing you might see if you walked down to a mountain lake early in the morning: the wind is clearing mist from a sheet of water beyond which you see a waterfall tumbling from a massive bluff. Our viewpoint is from the nearby shore which will frame the setting into a clearly defined composition. Can you see it? If you can then you're half-way to painting it!

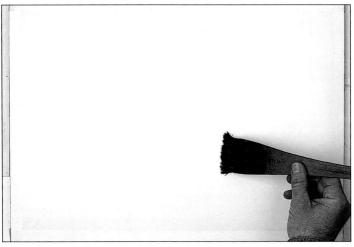

Wash in the background
Tape a piece of paper to the board and you're ready to go. Wet the whole page with clear water.

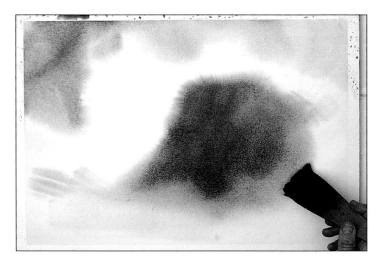

By referring to your three-line sketch you can now create a dramatic result, and one which will help to ensure the painting's success. Using a broad brush, and working wet-in-wet, lay in an evocative sky. Bring your blue in with a strong sweep. (Use tissues to establish the sharper edge in one or two areas.) Next comes the central landform. Bold simplicity will assist you to create the dramatic effect of a massive bluff emerging from mist.

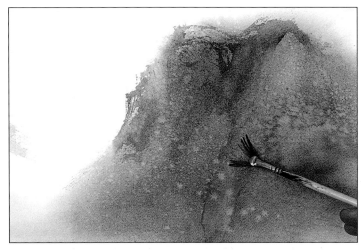

HINT

Reserving whites
The reserved whites in the sky are critical in this painting. They are echoed in the surface of the lake, which already suggests its presence below the bluff.

Establishing the tonal composition early on is rather like lighting an empty stage to await the arrival of the cast. In the white areas any details you paint later will be strongly contrasted while, within the dark mass in the center, the mountain already waits.

Start forming the rock with your split brush
While it's drying, you can work the face of the mountain, "breaking" the wash here and there with your split brush, moving wet pigment from one area to another with a rich "draggy" mark.

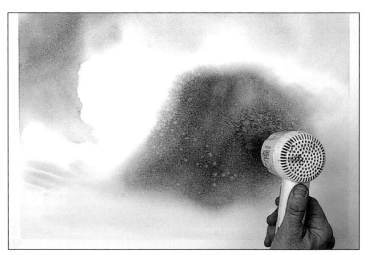

Reach for your hairdryer
In a studio, a hairdryer will hurry things along although it takes practice to ensure that one area does not dry quicker than another. Uneven drying poses challenges but unique effects can be created with practice.

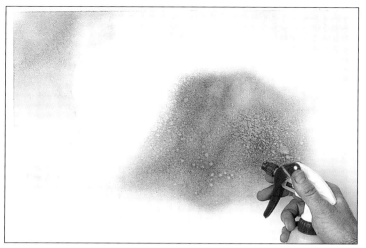

Spray to create a broken wash
The timely use of a fine sprayer (or spatter from a bristle brush or toothbrush) will scatter the drying wash here and there creating a textural effect.

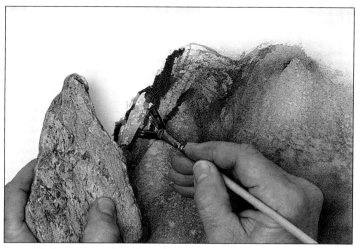

A rock helps you to visualize the mountain
A rock selected from your collection may be perfect to help you "form" the mountain. Using your split brush again, and with the rock to guide you, help the mountain to emerge from the wash.

To find out where you are, what to aim for, and what comes next, refer to the reproduction of **RISING MIST** in the **"Fold Out and Follow Me"** guide inside the back cover of this book!

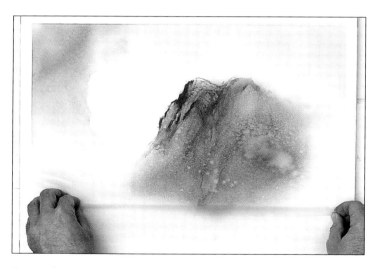

Create the straight edge on the lake
Let the picture so far be your guide. Perhaps you can already imagine the lake. You can? Great. Then put it right where you see it. Ensure that the first washes have completely dried. Now it's a simple task to lay down a strip of tape above the waterline of your imaginary lake. The lower edge of the tape will mask the paper.

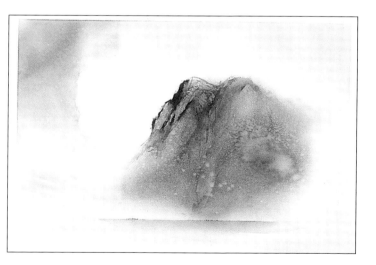

After wetting below the tape with clear water (and working wet-in-wet) charge the lake with blue before charging the upper edge with a touch of the grey you used for the mountain. Wipe along the tape with tissue and dry the wash as quickly as possible. Use tissue to soften any hard edges as they dry. Refer to the main fold out painting to see how this should look.

Use a razorblade to finish the lake edge
Place a metal ruler just above the upper edge of the lake and scrape along the edge with a safety blade. This will clean away any paint that has bled under the tape, and establish a crisp, white line along the upper edge of the lake wherever you want it.

Create the waterfall with a razorblade
Where should the waterfall go? I can already "see" mine! (I suggest you read the next instruction and then practice it on a scrap of paper first.) Place the metal ruler where you want the falls to go and then scrape out the main fall with the sharp tip of the blade. With practice you'll soon work out the best way of showing how the falls split as they run down the cliff before tumbling through space and crashing into the lake below.

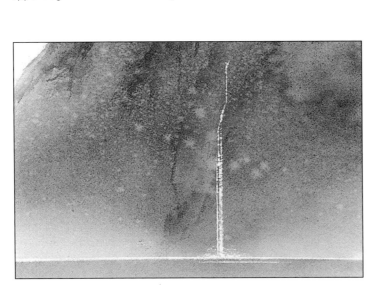

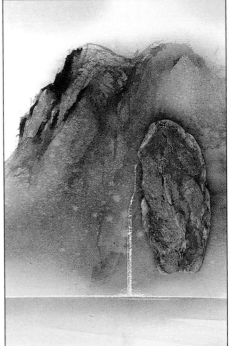

Where the waterfall hits the lake it's easy to establish misting spray by dragging the razor across with the blade laid almost flat. Take it easy — don't do too much!

Refer to a rock to further the effect
One of the rocks in your collection may be perfect as a reference for establishing the cliff around the falls. This rock is just right.

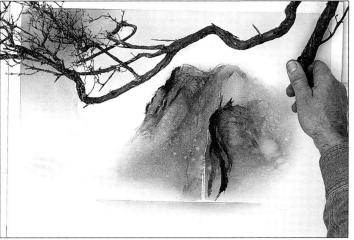
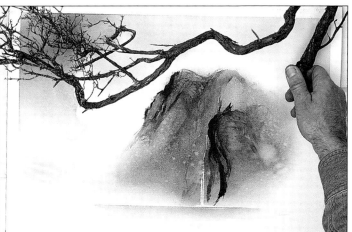

To find out where you are, what to aim for, and what comes next, refer to the reproduction of **RISING MIST** in the **"Fold Out and Follow Me"** guide inside the back cover of this book!

Draw direct using a suitable brush. Then use broad washes of blue to shadow this outcrop and the heights of the mountain. They will gain a solidity which they lacked before. See how this has been accomplished in the main fold out painting.

Position the trees

Here is an "idea starter" for you. A piece of driftwood from my studio collection offered the opportunity to think about making a dynamic change to the composition. A descending branch from a nearby tree cutting across the sky would provide a strong compositional element. However, it was an option I rejected.

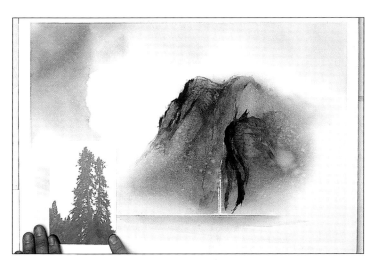

Instead, hunt around in your photo collection. The one I located of these tree silhouettes was perfect for this task. These trees immediately give us a foreground.

Smaller trees in the distance are another possibility. My collection yielded some more ideas. Combining photographs gives even more options. In this case the photographs showing trees leaning from the right will lead the eye in from the corner and over towards the more distant group.

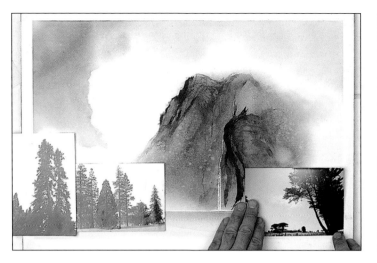

Adding the original grouping creates a sense of perspective.

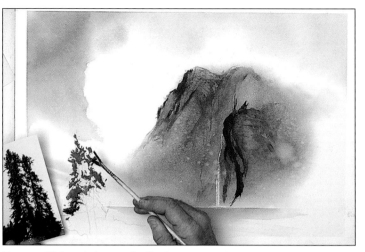

Use a split brush to create the trees
After deciding where you want the trees, make a simple outline sketch of the tree shapes in pencil and then, using the dry brush approach, start to build up the foliage with your split brush, or any other brush which makes suitable marks.

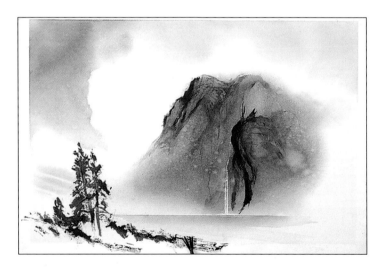

After establishing the foliage in general terms and then dragging in the trunks, it will be quite natural for you to continue the same dry-brush approach for the slope on which the trees stand.

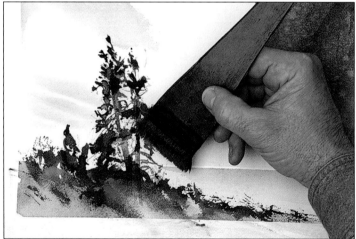

A broad brush and variegated wash suggest grass
By loading up a broad brush with multiple colors you can create the sweep of grasses down to the shore.

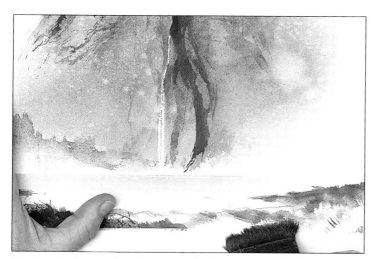

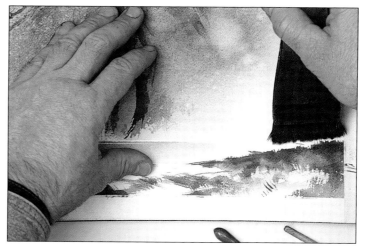

To find out where you are, what to aim for, and what comes next, refer to the reproduction of **RISING MIST** in the **"Fold Out and Follow Me"** guide inside the back cover of this book!

Try to create the effect of the breeze clearing away the mist. You may notice in the fold out that the tree are also affected by this breeze.

Work over to the headland, including the area on the right which juts out into the mist. Remember, the white areas you don't paint can be just as important as the areas you do. You can see what I mean when you look at the finished painting on the fold out page.

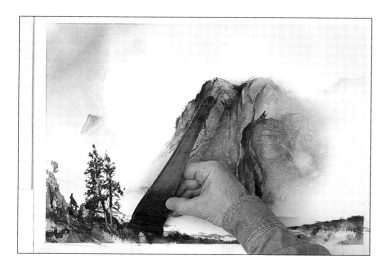

When the foreground brushwork has dried, lay a variegated wash over it to establish the play of warm and cool local color. Remember that these colors will have an important effect on your composition.

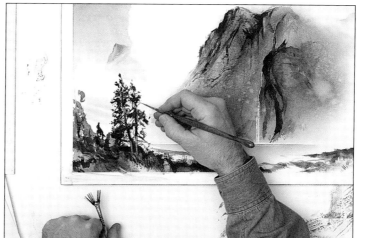

Detail the foliage
Your fine brush will be perfect for flicking in tiny branches.

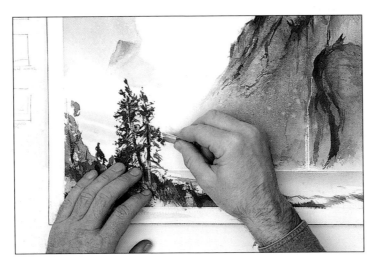

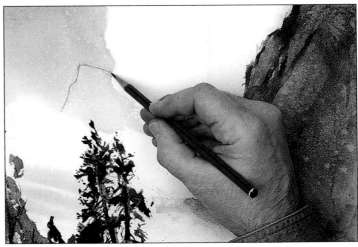

A razorblade can be used to enliven your trees still further. Scratch out a few lighter branches, or open up the foliage here and there. Are your trees taking on a life of their own?

Add a distant peak with a traditional wash
Any distant peak seen beyond the cloud would fade away at its base. Start by drawing the outline.

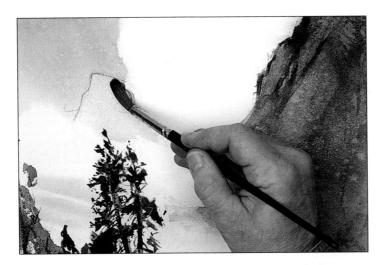

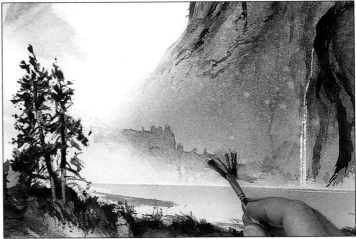

Wet the space up to the outline, then charge this with blue and darken its peak with a touch of a suitable tone (the color you used for the bluff will do fine.) Carefully dabbing at the drying edge with tissue will help you blend the edge. See how this looks in the finished fold out painting.

Create misty trees on a distant slope
Establishing distant trees on a slope seen through rising mist is easy. Select a pale wash of the color you used for the mountain and work along with your split brush pushing the top edge of the slope upwards here and there. Use a tissue to ensure that the lower edges and ends of this outcrop blend into the mist.

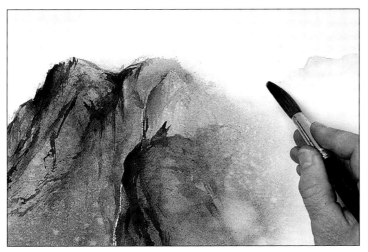

To find out where you are, what to aim for, and what comes next, refer to the reproduction of **RISING MIST** in the **"Fold Out and Follow Me"** guide inside the back cover of this book!

Lead the eye with another peak

A suggestion of further peaks in the upper right corner is an easy way to lead the eye into the composition. A very pale wash with a little detail makes this a relatively simple task.

Timely work with the tissue is very important to ensure that this blends.

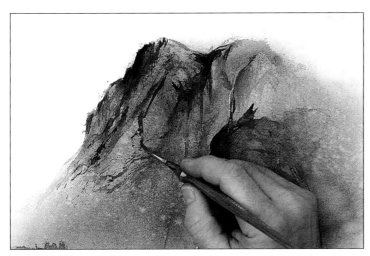

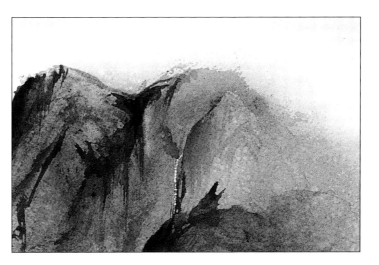

Make finishing touches to the mountain

At this stage you can add whatever details you like to the mountain, as long as you work within its bulk and protect the reserved whites around it.

Alternate split brush and fine brush work allow you to build up any details you like. As you can see here and in the main fold out painting, the waterfall now tumbles from a higher point, travels behind the outcrop of rock and then falls from somewhere behind it.

113

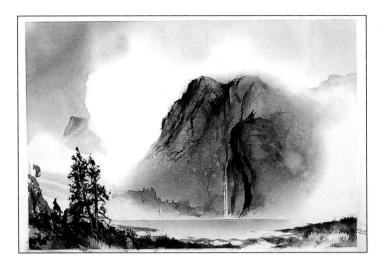

Here's how it looks so far. Is it finished?

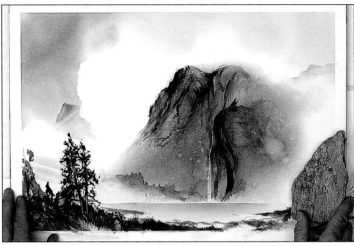

Take a chance with the composition

On an impulse I decided to add a cliff to the righthand side. Doing this sacrifices an area of misty white and its subtle relationship with the grassy promontory, but adds a strong element to frame the composition. I used a rock again to see what the painting would look like with a nearby cliff. Changing composition at this stage can be a risky exercise, but it's a good example of how you can change course anytime. There are no rules in watercolor, only consequences.

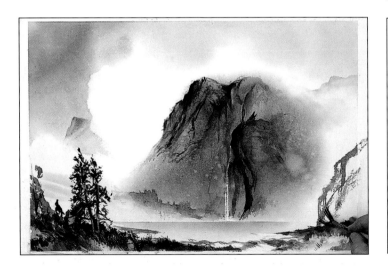

Sketch the basic shape with wash and brush before filling in the rock and adding details.

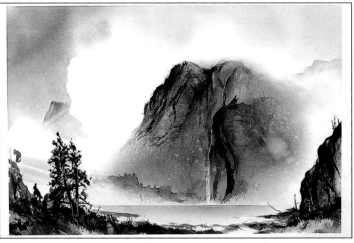

A tiny trunk or two creates a subtle impact, breaking up the outer edge of the cliff — which is perhaps stronger and darker than I intended. The little trunk leaning out into the water links the shoreline with the open sheet of water.

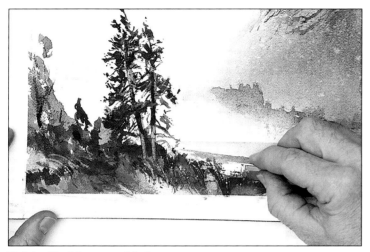

To find out where you are, what to aim for, and what comes next, refer to the reproduction of **RISING MIST** in the **"Fold Out and Follow Me"** guide inside the back cover of this book!

Finish off with a razor blade

Here and there the grass can be enlivened by scratching back a few blades of grass. It's finished!

Compare your version with the fold out "Rising Mist" painting inside the back cover. Remember it doesn't have to be identical.

Analyze the composition

It's interesting to compare the finished picture with the earlier color sketches which established the game-plan, and the first washes which established the formal elements around which the picture was created.

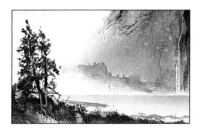

You may find there are some areas that work better than others, or smaller compositions within the larger picture that will give you ideas for the other paintings. It's all part of the creative process.

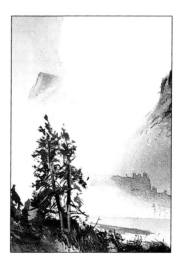

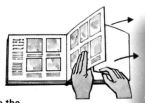

1. **Go to the "Fold Out and Follow Me" guide in the back of the book**
Look for the reproduction of "Riding the Wind" on the fold out page inside the back cover.

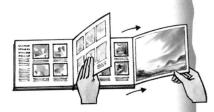

2. **Fold out the finished painting**
Carefully fold out the page so you are able to view the finished painting while turning pages of this chapter.

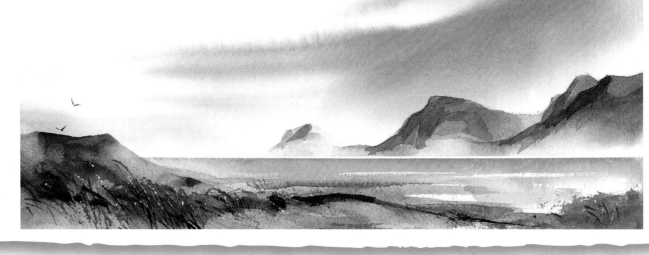

"Riding the Wind" Watercolor 8³/₄ x 12³/₄" (222 mm x 324 mm)

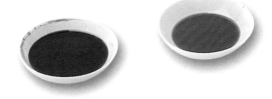

Another complete project which will inspire you to create your own original landscape.

PROJECT 2

How to recreate the "Riding the Wind" landscape project

3. **Follow the stages to recreate this landscape project**
As you follow this step-by-step project, you can instantly refer to the folded out painting to see what stage you are at, what to do, and what comes next.

Most people take their beach vacations in summer, which is a great time for the kids to swim and surf. But my favourite time is the fall when the days are closing in and the shadows a little longer. In the fall we take long walks with friends along the dunes and in the marshland near the harbor village where we rent a beach house. The kids are not so "water-focused" then and are happy to explore the countryside around the bay — scrambling over rocks and watching the seabirds soaring over beaches largely deserted after the rush of vacationers only a few months before.

I associate the fall with a slightly hazy atmosphere, light breezes with a hint of warmth and the promise of colder days ahead. The wind seems to carry all before it, one minute the leaves from a nearby tree, and the next a swooping gull; while up above, a thin layer of clouds is blown away in streamers of white. I love it.

I'm going to demonstrate the processes involved in painting "Riding the Wind" which you'll find in the "Fold Out and Follow Me" section at the end of this chapter. I hope you'll work along with me again and create your own original landscape.

This is a very straightforward painting using a limited palette. In fact, it's a simple painting! Tonal values build up gradually from from light to dark and so you should be able to work along with me very easily. Pale washes create a setting, then shadows and details are added in successively stronger washes. It's also worth noting how the first broad washes require big-brush technique, and the final details, especially the two birds, require a mere flick of the finger with the finest-tipped brush in your collection!.

Remember: your painting can, but need not, look exactly like mine. This is a creative adventure! Remain open to the opportunities for creativity that painting presents and allow the picture to evolve. My demonstration is only a technical reference to help you do your own thing. It's like a map, which suggests a possible direction, but should always leave you free to chart your own course!

And don't be in a hurry. The most exciting thing in the world is an empty sheet of paper awaiting the first stages of a watercolor. Too many people rush to finish, frame, and display their finished work. However the real fun lies in doing the painting, and discovering those creative opportunities which will certainly arise as you go along.

Once again, I'll show you each stage: the colors, preliminary sketches, color notes, washes and brushes. By referring to the fold-out of the finished painting you'll be able to see the impact of each element as it is added and then apply them to your own painting.

Consider the composition in thumbnail sketches

Just as for the first project, tiny three-line sketches are a great way to consider your options. You can establish landforms, horizon, and foreground details anywhere at all. I chose to emphasize the sky, which will provide a vast windswept backdrop to the drama of birds at play.

Explore design elements in larger sketches

Slightly larger sketches enable you to also play with landscape elements; to experiment with shadowing; and to consider your brushwork. And they don't tie you down for, on the contrary, they serve to remind you that there are lots of ways this painting could evolve!

The palette

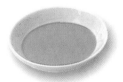

YELLOW OCHRE
Grass area.

COBALT BLUE
Sky and sea.

CERULEAN BLUE
Unifying and shadow blue

Further colors you will need

A strong gray, made up by adding a small amount of Phthalo Blue to a greater quantity of Light Red (areas of shadowed grass).

A gentle gray, made by adding a lesser quantity of Light Red to a greater quantity of Cobalt Blue (shadows along the hills).

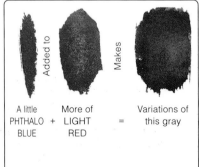

A little PHTHALO BLUE + More of LIGHT RED = Variations of this gray

Added to Makes

Preliminary color notes

Two or three simple color notes help you to prepare your palette and the shadow tones that will be so important. Color notes are not major paintings and should not limit your creative options; they help you to identify the possibilities. And they prepare you for the challenge ahead! Along the way, your painting will evolve and you may suggest a concept something quite unlike and possibly much better than any of your preliminary studies. Creative watercolor allows you to be creative THROUGHOUT the painting process.

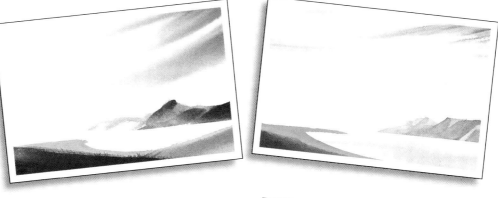

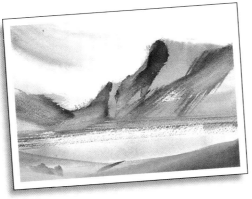 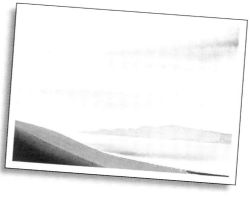

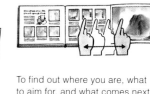

To find out where you are, what to aim for, and what comes next, refer to the reproduction of **RIDING THE WIND** in the **"Fold Out and Follow Me"** guide inside the back cover of this book!

Wet the sheet

Begin with the sky, which is in fact a key element in both the picture and the story it tells. Use a hake or similar wash brush to wet the sheet with clear water. (Perhaps this should be called "laying a clear wash"?) With practice you will soon learn how much water to lay, depending on what sort of wet-in-wet effect you hope to achieve.

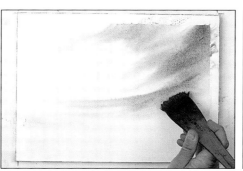

Sweeping brushwork creates the blue of the sky

Reload the brush with a pale wash of Cobalt Blue and create the sky with a few diagonal sweeps of the brush. Imagine the wind sweeping the clouds away as you do so. The clouds are actually created by the negative spaces in between your blue brushstrokes.

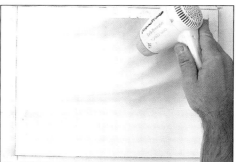

You can soften the clouds with a dryer

Use your hairdryer to soften the cloud-shapes and to flatten the granulations. Make sure you move it back and forth to ensure even drying or you may find some very un-cloudlike shapes appearing in the sky!

119

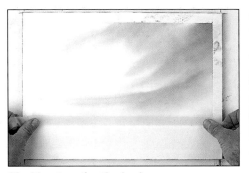

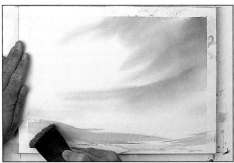

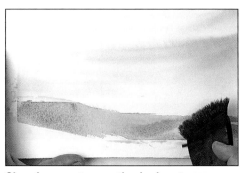

Masking tape for the horizon

When this is completely dry, use invisible tape or masking tape to establish the distant horizon. Skip ahead a few illustrations and you'll see how the lower edge of the tape will soon be used to create the upper edge of the ocean. (But do remember that some papers cannot handle tape as a method of masking and will tear. You must have a hardy paper for this technique. For delicate papers you might try a removable tape, but you'd have to test it thoroughly.)

A broad sweep for the land

Load the hake with Yellow Ochre (remember to rinse out the previous wash first) and use this to establish the broad sweep of land leading out to the ocean. The upper edge will become the shoreline.

Charging creates gentle shadow tones

Quickly reload the brush with your pale Cobalt Blue and use this to charge the Yellow Ochre here and there to create a blended green toning which now hints at shadow-play across the foreground.

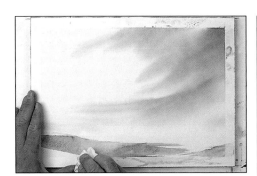

Lift the wash to create softer edges

You can create a few lighter patches and soften the edges by immediately dabbing or wiping here or there with a clean, dry tissue.

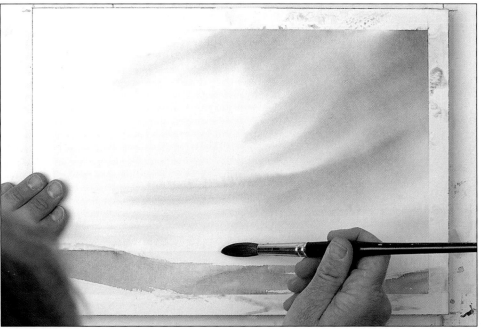

Wet-in-wet for the ocean

Now for the ocean! Wet the unpainted area directly below the tape with clear water.

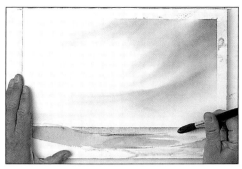

Load your sable with a stronger wash of Cobalt Blue and charge the wet area. Don't worry too much about the lower edges. On the right where the blue has crossed the nearby yellow it suggests a shadowed area and where it stops well back it has reserved a crisp area of white along the shore.

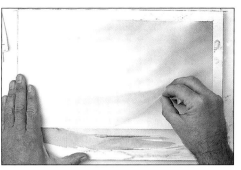

After this is completely dry you can remove the tape. Peel it away from the painted area.

A special masking technique using more tape
This time use tape to cover the water up to the horizon AND JUST OVER THE EDGE. This means that you will not disturb the horizon when painting the hills and, that there will be a thin "white" line above the horizon. Refer to the finished painting in the fold-out and you'll see what I mean. It's a great technique with lots of applications!

To find out where you are, what to aim for, and what comes next, refer to the reproduction of **RIDING THE WIND** in the **"Fold Out and Follow Me"** guide inside the back cover of this book!

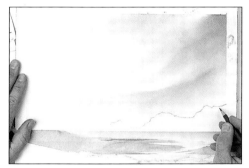

A pencil sketch creates distant hills
It's not hard to imagine a range of distant hills floating in a misty haze on the other side of the bay. Use a light, fine pencil to draw them in, receding into the distance.

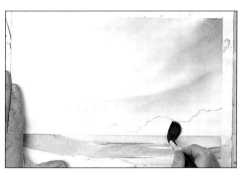

Variegated wet-in-wet for the hills
Reload your sable with clear water and wet the area right up to the upper edge of the mountains. This should also run right down to the tape covering the blue water

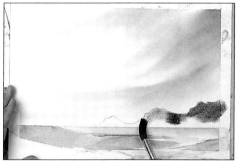

Working from the right, charge this with the gray made of Cobalt Blue and Light Red and variegate it to Cobalt Blue as the hills recede into the haze. In the next few photos it may look as if there is no wash at all on the left and most distant hill, but this will not seem so apparent when the shadows are added and the pencil rubbed out. (Please refer to the finished painting and make your own decisions when laying your wash.)

121

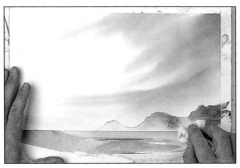

Use tissue to accentuate the haze
Work along the lower edge with a dry tissue, lifting the wash away from the horizon so that the hills appear to "float" above the haze.

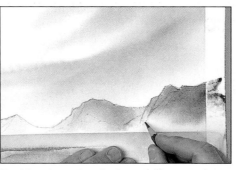

Decide where the shadows will go
Lightly sketch in the folds of the hills to guide you in painting shadows.

Flat brush to paint the shadows
Load a flat wash brush of some sort with the gray and use this to establish the shadows which run down the face of the hills.

Soften the shadows
Before this dries, reload the brush with clear water and soften the lower edges of the shadows.

Change the shadow color
Now repeat these processes to create the furthermost shadows but using Cobalt Blue instead of the gray.

The shadows are important. They heighten the three-dimensional illusion and give the strongest indication of direct sunlight in the painting.

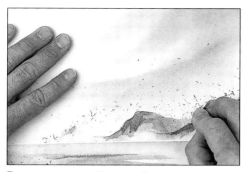

Erase to remove the pencil sketch
When the paint is completely dry you can use an eraser to remove the pencil lines.

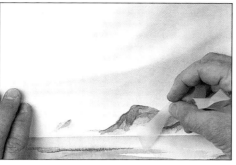

Remove the tape
Carefully peel the tape away and (if you followed my suggestion when laying it down) you should find that there is a clear white line between the blue and the mountain. This is the sort of effect you occasionally observe on sea or lake when looking into the light, and is a great pictorial device which you can also use when painting the play of light on a dark body of water.

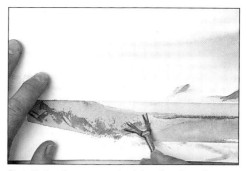

Detail the foreground with a fan brush
Up until now we have worked with relatively pale washes. Now we'll move into mid-tones. I have a favourite old hog hair fan brush which I use for the next stage, but a new one will achieve a similar result. Load the brush with a stronger value in the Yellow Ochre and/or blue and gray and start to suggest the nearby grasses. Try to bring the grass to life in your imagination, and let your imagination work in hand with the composition so that you sense where the grass should go.

To find out where you are, what to aim for, and what comes next, refer to the reproduction of
RIDING THE WIND
in the
"Fold Out and Follow Me"
guide inside the back cover of this book!

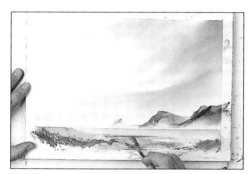

Continue to build on this effect using the Yellow Ochre, blending areas of yellow with Cobalt Blue and either of the grays.

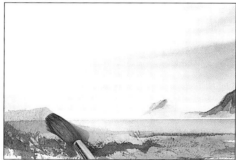

Add to the middle-distance with a stronger wash
Remove the tape, then load a brush with a strong solution of Yellow Ochre and build up the slope on the left. This now juts into the sky.

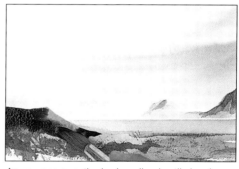

As you can see, the horizon line is still showing through this slope. We'll address this in a couple of ways. First, charge the shadow side of the slope with a small amount of the darkest gray (which in this case is closer to a dark brown because of a predominance of Light Red over Cobalt Blue in the mix). Use this to create a shadow which is "soft" in comparison to the crisp shadows on the distant hills. Later, when we lift a light area on the other side of the slope, the line will no longer show through.

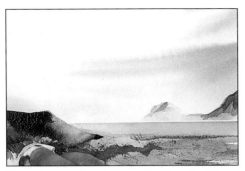

Use a tissue to break the wash, lifting it a little on the lighter side.

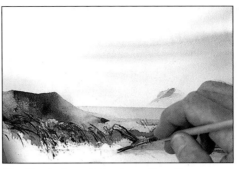

Use the dark wash to strengthen the grasses
This is a good stage to continue working on the nearby grasses. Make sure the work so far is dry, then load up that old fan you have with a very dark wash and continue building the nearby grasses

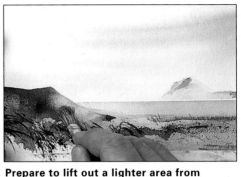

Prepare to lift out a lighter area from the slope
Dip a stiff bristle brush into clean water and use it to wet and disturb the "sunny" side of the nearby slope.

Use tissue to lift
Hold a clean, dry tissue firmly and wipe away the dampened pigment. This will not only lighten the Yellow Ochre with which we established the slope, but will also break the tape-line which might otherwise still show through the wash. The slope now has a more rounded appearance.

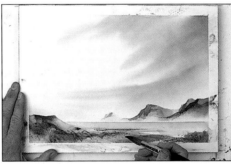

Cerulean Blue creates unifying shadows
Using a soft brush lay a subtle wash of Cerulean Blue over the nearby slope. This creates a gentle shadow which can run wherever you choose to give form to the foreground, and also links it with the middle distance. Extend the shadow wash out towards the nearby shoreline and then remove some of it here and there with a tissue which will soften it.

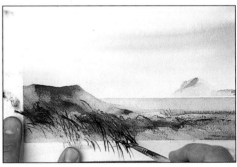

Add final details for the grass
Reload your fan with dark wash and flick in the final strokes that will finish off and enliven the grassy area in front.

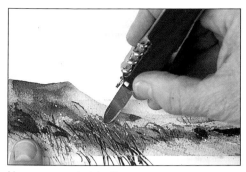

Use your pocket-knife
Use your pocket-knife to drag out a few blades of grass here and there.

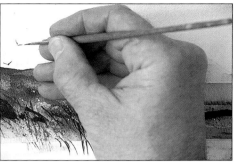

Paint the birds with a #00 brush
Happy that I could place them in harmony with the prevailing winds, I flicked in two birds in with my finest brush. In the context of the painting those birds might be quite large creatures, but here, at the moment of their creation (and in comparison to a "giant's hand") their scale in reality is much clearer. It seemed to me that, if I were a bird I'd be riding the wind over the knoll.

Finished yet?
Not quite finished. The flat expanse of the sea is effective, but dull.

To find out where you are, what to aim for, and what comes next, refer to the reproduction of **RIDING THE WIND** in the **"Fold Out and Follow Me"** guide inside the back cover of this book!

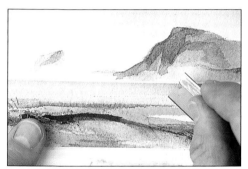

A blade creates distant waves
To enliven the water, use the sharp corner of a blade to scape away a few crisp horozontal waves near the shoreline. I thoroughly recommend that you practice this on a scrap of paper first. You may also find it helpful to use a ruler as a guide while scraping, or to lightly pencil in the wave locations first. (Have a look at the waterfall in the previous "Rising Mist" fold-out),

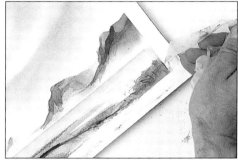

Peel away the tape
If your painting is taped to a board then very carefully peel the tape away from the painting. If, as I have, you've been working on a gummed block and only laid down an edge of tape for the white border it creates, the same will still apply: please be very careful not to tear the painting!

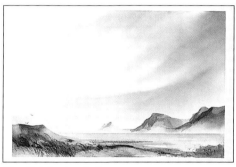

The finished painting.
It's interesting that when you identify and show each stage of a comparatively simple painting it is actually quite complex!

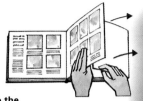

1. Go to the
"Fold Out and Follow Me" guide
in the back of the book
Look for the reproduction of
"Evening Light" on the fold out page
inside the back cover.

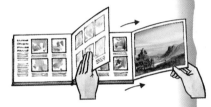

2. Fold out the finished painting
Carefully fold out the page so you
are able to view the finished
painting while turning pages
of this chapter.

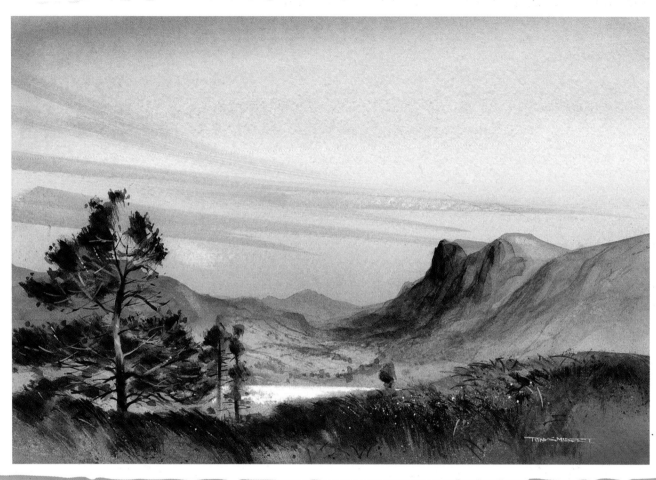

"Evening Light" Watercolor 9 x 13¹/₈" (230 mm x 334 mm)

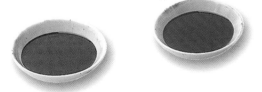

The creative processes shown here will help you develop
your skill and confidence.

PROJECT 3

How to recreate the "Evening Light" landscape project

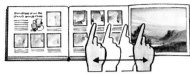

3. **Follow the stages to recreate this landscape project**
As you follow this step-by-step project, you can instantly refer to the folded out painting to see what stage you are at, what to do, and what comes next.

Here's an opportunity to apply some of the most traditional watercolor techniques to painting a valley landscape suffused with warm evening light

You may like to imagine a location near your home, or a favourite vacation spot. A photo may provide you with a great starting point; you might find it best to work from sketches, or simply work along with me.

In my case I'm painting from memory. Nowhere in particular: just an area not too far from home.

I have in mind the way mountains change color as the sun sets; and in particular the muted colors that play across the fields below when you climb to a vantage point above a valley.

As you'll see from the project, it evolved throughout the painting process. I think I could (maybe should) have stopped a number of times when the painting was working well. And because I do believe that simple is best, I think the final result is probably overworked.

However, I wanted to demonstrate two things:

a) The evolution of a painting from an original concept.
b) A number of traditional processes in action.

I want you to feel that you can do it too! And I hope that you'll find lots of ways to organize and re-organize the elements of composition, color, process and conclusion to create your own original works.

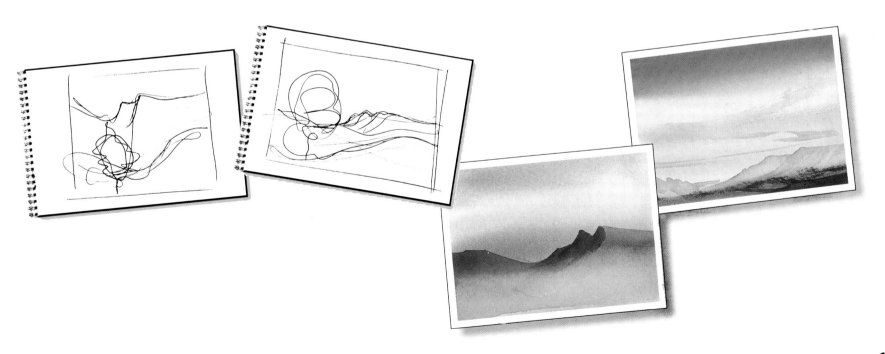

127

Simple sketches to plan the composition

Previously, I recommended "power doodling" as a creative sketching method. This time, in an extension of that idea, use a ball-pen to explore the possibilities of the subject. Let the pen roam over the sheet, exploring not only the landforms and other elements of your subject, but the possible rhythms and directions of brush-strokes. Free-flowing drawings are a great way to overcome any inhibitions you may have about sketches. I'm inclined to call this "scribble-sketching" because you should also be totally uninhibited about the number of lines you draw.

The compositional elements are few: sky, distant hills or mountains, the foreground and one or two trees. Plenty to work on!

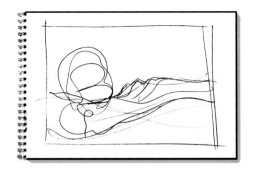

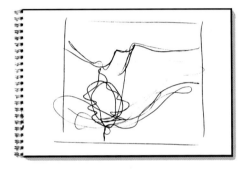

The palette

| YELLOW OCHRE Sky, hillside, grass and foliage | LIGHT RED Sky and mountains | COBALT BLUE Sky, mountains and shadow | CERULEAN BLUE Unifying blue | PAYNE'S GRAY Areas of foliage | LAMP BLACK Branch, grass and foliage details | RAW UMBER Foreground textures |

Mixing further colors

Dark gray, made up of Light Red plus Phthalo Blue (foreground slope and shadowed areas of foliage).

Lighter gray, made up of Cobalt Blue plus Light Red (mountain shadows and some details)

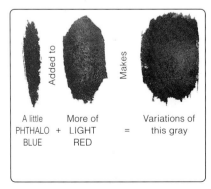

A little PHTHALO BLUE + More of LIGHT RED = Variations of this gray

Added to / Makes

The color notes

This painting re-addresses many of the challenges you met with "Sunset over the Valley" in the chapter, "Traditional Techniques Make it all Possible" (see page 38). The most important challenge in "Evening Light" will be the establishment of overall color values with a wet-in-wet variegated wash. This is the first stage of a quite complicated painting and everything else depends on it. Because the painting shows the deepening last notes of color over a rural valley, these colors have to provide a warm glow that will pervade everything.

Color notes are essential to this painting because you must decide which colors to use, determine the wash strength and decide in which order to introduce them to the paper. I suggest you try a number of color notes first, because you may decide to use different colors from mine, so feel free to experiment!

How the painting will progress

This painting begins with broad washes applied with a wide brush to establish the sky and the color values that suffuse the entire work. Next, basic washes with medium sized brushes build the major landforms and establish local color values. The pattern and rhythm of grass and trees will follow using a range of brushes, and then the final details will be created using finer brushes and blades — even toothbrushes — until, at the last stage, the white paper is finally reclaimed from the image by using a blade and ruler to scrape away the upper surface of the paper.

The painting is traditional, but controversial, in that it makes use of black (a color which many contemporary painters will not have in their palette), and it also makes use of bodycolor here and there. I would like it to help you explore the possibilities of some of these traditional techniques. You should feel free to adapt or reject them in the evolution of your own landscapes — and indeed your own approach to watercolor!

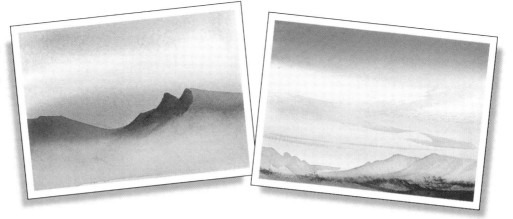

To find out where you are, what to aim for, and what comes next, refer to the reproduction of **EVENING LIGHT** in the **"Fold Out and Follow Me"** guide inside the back cover of this book!

STAGE ONE:
BROAD WASHES, COLOR VALUES

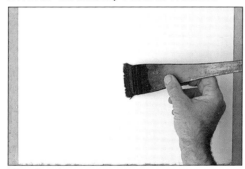

Wet the sheet
After taping it down, thoroughly wet the sheet with clean water and even this out with a hake.

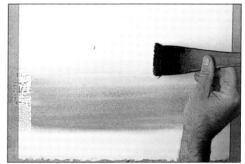

Create sunset colors with a variegated wash
Working wet-in-wet lay a broad band of Light Red right across the sheet.

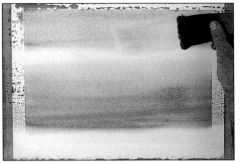 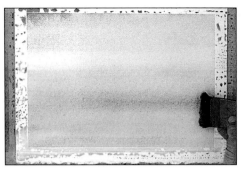

Warm the lower (foreground area) with a band of Yellow Ochre. The trick is to blend all these colors without overworking them. If you overwork them the result will be much muddier. When the wash is complete, use a clean, dry tissue to mop up any excess wash from the taped area around the sheet. This will help you to avoid any bleed-back along the edges and the risk of picking up any of this pigment during later stages.

Then lay a broad band of Cobalt Blue to establish the upper sky.

STAGE TWO:
TRADITIONAL WASHES CREATE THE LANDFORMS

 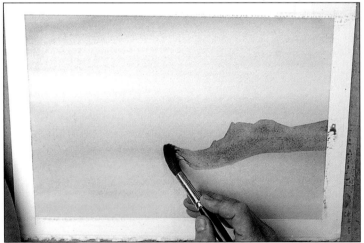

Hairdryer to dry and flatten the wash
At this point you can (but need not) use your dryer to hurry things along. In this instance it will flatten the wash, removing evidence of brush marks and so may be desirable. Despite my own best advice I'm always excited and can't wait to get on to the next stage!

A variegated wash creates evening light on the hills
Once this stage is completely dry, angle your painting surface so that the painting board slopes towards you and then establish the mountains, starting with Cobalt Blue.

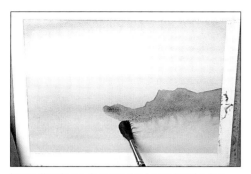

Immediately wash away the lower hard edge with clear water to create a gradation.

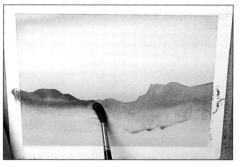

Suggest warm light on the distant ranges
Without pausing, rinse and reload your brush, this time with Light Red, and bring in an adjoining range. If necessary, wash away the lower edge with clear water to create a gradation.

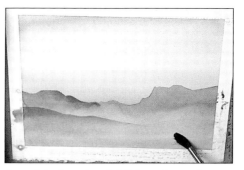

A gradated wash establishes closer slopes
Create the middle distance with a gradated wash in Yellow Ochre, gradate it by washing away with clean water. Don't forget to refer to the "Fold Out and Follow Me" painting from time to time.

To find out where you are, what to aim for, and what comes next, refer to the reproduction of
EVENING LIGHT
in the
"Fold Out and Follow Me"
guide inside the back cover of this book!

STAGE THREE:
CREATING PATTERN, RHYTHM, TEXTURE

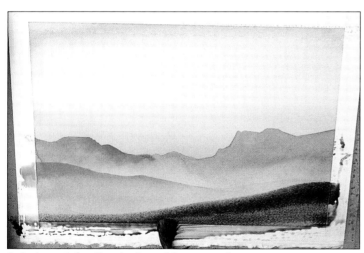

A dark wash for the shadowed foreground
While the foreground is still wet create the foreground slope with a wash of the darker gray (the Phthalo Blue/Light Red mix).

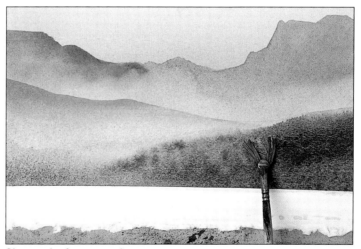

Charge the foreground to create texture
Use your fan brush to charge the foreground here and there with Raw Umber and/or Yellow Ochre

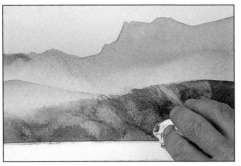

Wipe with tissue to enliven with light
Use a clean, dry tissue to soften this area by lifting some of the pigment. You'll see the effect we're aiming for in the finished painting.

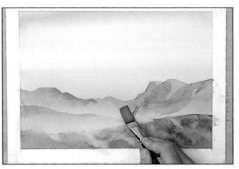

Run cool shadows for the cool colored areas
Run cool shadows down the face of the blue mountain using a flat wash brush and Cobalt Blue.

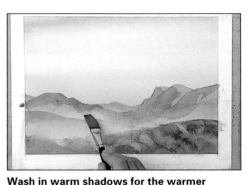

Wash in warm shadows for the warmer colored areas
Where the warm evening light strikes the distant ranges, use a light wash of local color (the Light Red) to shadow them.

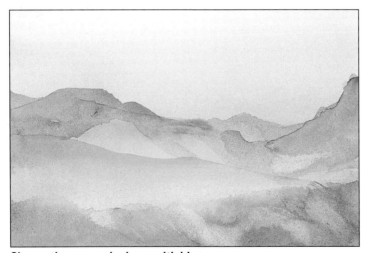

Charge the warm shadows with blue
Now, for a slightly more sophisticated approach to the shadows. Charge this warm shadow area with some of the Cobalt Blue. (Take a peek at the "Fold Out".)

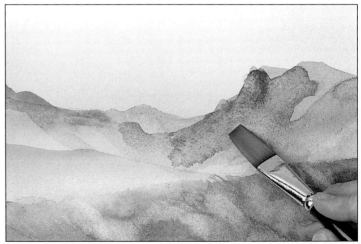

Charge the cool shadows with warmth
Charge the cool shadows with some Light Red (reflected from the warm face of the other range). The result is dramatic, linking the two faces of the range in a way which is much more exciting than merely shadowing with local color, (which was advocated by Albrecht Dürer in his time) or even laying a single shadow wash of various tones in the manner of the 18th century.

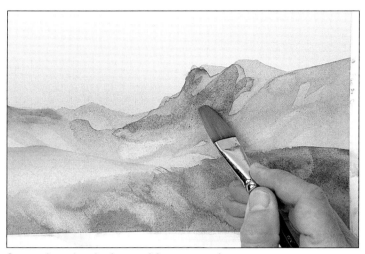

Strengthen the shadows with more wash
Use Cobalt Blue to lay a slightly deeper shadow over the mountains.

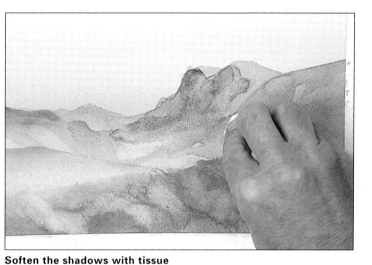

Soften the shadows with tissue
Blend the edges of the shadows here and there by dabbing with a tissue. It takes practice to get this just right, but it's a powerful tool in your armoury of techniques, once you feel confident with it.

To find out where you are, what to aim for, and what comes next, refer to the reproduction of **EVENING LIGHT** in the **"Fold Out and Follow Me"** guide inside the back cover of this book!

STAGE FOUR:
FINER DETAILS

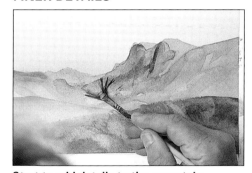

Start to add details to the mountain
Using an edge of the fan brush add some shadowed details to the face of the bluff. This does not require the sort of detail we brought into the "Rising Mist" project but instead only hints at cracks and crevices among the exposed cliffs.

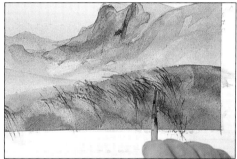

Suggest nearby grasses with a fan brush
Using the very tips of the bristles and dark wash, use your fan brush to suggest the blades of nearby grass, on a rise which is obviously subject to wind from time to time.

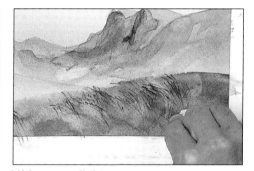

Lifting some lighter grasses
While these strokes are still wet you can use a tissue to firmly wipe away a few of the blades to create lighter blades.

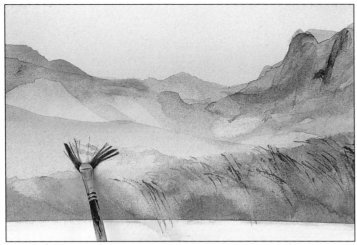

Scumbling grasses with the ferrule
Load the fan with a warm colored wash and use it to scumble the texture of windswept grasses on the middle slope. (At this stage I thought the middle-ground would resolve into a nearby hillside. Later on however, when the painting had evolved further, I decided that this area was actually a distant area. In any case, this grass effect was eventually concealed by foreground trees, turn to the "Fold Out" and see what happened.)

Spatter in the foreground texture
Load a toothbrush with clear water and spatter the foreground. You can easily mask the area beyond with your cupped hand.

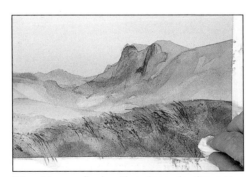

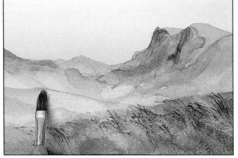

Wipe this very firmly with a clean, dry tissue to lift the moistened pigment and create a subtle texture as might be seen in a meadow.

Wet and wipe to lift out a sunlit area
Using a firm bristle brush wet an area in the middle ground then wipe it away with a clean, dry tissue to create the effect of warm, but muted sunlight.

 The painting could actually be "finished" at this point. Compare it with my final result and ask yourself: should I have left well enough alone?

Reassess the composition
To help consider my options I often use my hands to mask a work in progress. Here, I'm concealing the warm area in order to evaluate the relationship of the grassy rise to the mountain.

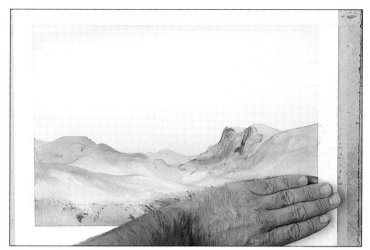

To find out where you are, what to aim for, and what comes next, refer to the reproduction of **EVENING LIGHT** in the **"Fold Out and Follow Me"** guide inside the back cover of this book!

And here, I neutralised the foreground in order to consider the play of light over the middle and rear-ground.

Orchestrate the composition

I remember a distinguished Australian watercolorist describing this next stage as "orchestrating". This is where you consider most carefully the relationship of all the elements in your "performance", and find ways to balance and integrate the various areas of interest within your composition. The aim is to bring these elements together into a working harmony of color and rhythm (or disharmony, if you choose — for there are no rules!).

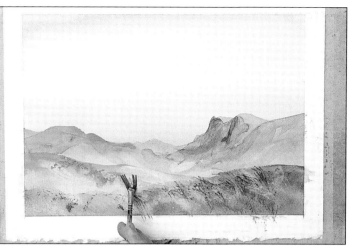

Suggest the shapes of distant trees by scumbling

To throw the middle-ground back into the distance, use your fan and warm wash to scumble the effect of distant trees. Don't be inhibited by this: let the brush do the work for you, let it feel its way over the surface.

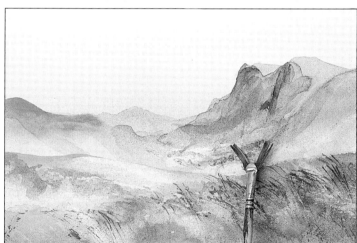

Suggest distant trees within the shadows

Reload the fan with blue and create a suggestion of distant trees in the shadowed folds of the distant valley.

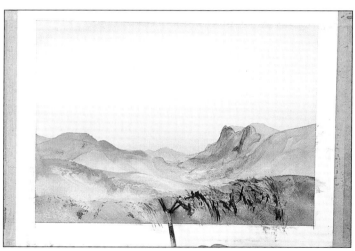

Add more detail for the foreground

Using the same brush to work each of these different areas (middle, rear and foreground) is a great way to create a "textural" harmony. Load your brush with a very dark wash, (the dark gray, or Lamp Black are fine), and flick in a few strongly identified blades of grass nearby. These will speak for all the other blades. (These wet strokes appear too dark, but I'm relying on them appearing a little less aggressive when they dry.)

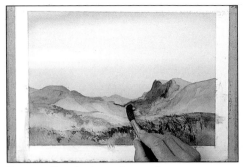

Deepen the shadows to create a "solid" mountain
To give the bluff a greater presence, deepen the shadows along the face using the gray made by mixing Cobalt Blue and Light Red.

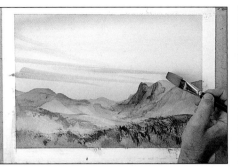

Dry-brush to bring the sky to life
Use very little of the same wash to create sweeping clouds across the sky. Such dry-brush strokes require you to be very decisive. Notice how they taper away towards a vaguely felt vanishing point somewhere off-stage to the right.

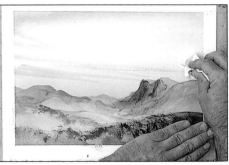

Use tissue to lift part of the cloud
Before this dries lift some of it with a tissue, taking care to wipe along the brush sweep, not across it. It's risky, but what is life without a little risk? At this point I was also using my hand to mask the foreground, and decided to cool the foreground shadows.

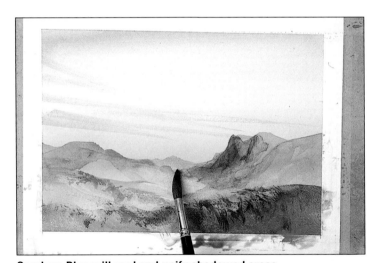

Cerulean Blue will cool and unify shadowed areas
To "color" the predominantly dark shadows of the foreground and to unite them with the shadows cast by the bluff, lay a strong wash of Cerulean over the foreground grasses and a gentle wash of the same color over the distant cliff-face and extending into the valley. The warm shadow area I was so pleased with earlier, is almost gone; have I gone too far?

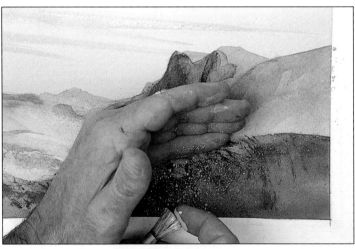

Bodycolor spatter makes great grasses
Using your hand as a mask, load a bristle brush with bodycolor (Chinese White warmed with Yellow Ochre is perfect) and spatter the foreground grasses. This greatly enlivens the area. Bodycolor, being opaque, sits on the surface of the darker area and creates a sense of depth.

Review the composition
Once again, perhaps the painting could have finished here!

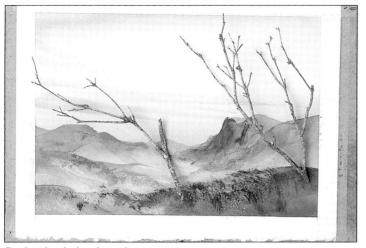

Real twigs help place the trees
Using twigs, you can imagine any number of options for placement of trees. Could we be standing on the outer edge of a small wood?

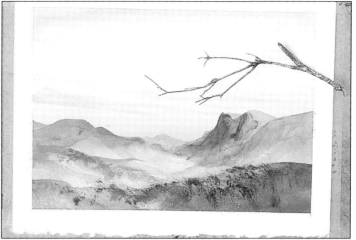

Perhaps a branch (suggesting a nearby tree) would enhance the composition?

To find out where you are, what to aim for, and what comes next, refer to the reproduction of **EVENING LIGHT** in the **"Fold Out and Follow Me"** guide inside the back cover of this book!

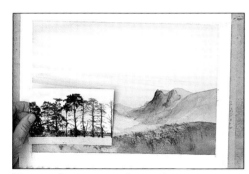

Photos give you creative options
Photos, once again, are a great way to try out some of the many creative options available and enable you to preview just how these might look. Referring to my own collection, I first considered a group of ancient pines on the second rise.

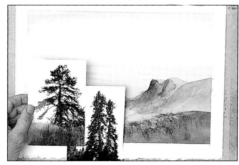

At this stage we only have to consider their general characteristics: things like size, density of foliage, the number of individual trees and their impact on your composition. After considering a number of options I've decided that this tree will form the major element in the foreground and that the tops of the other two trees will help me to create a couple of other trees further away.

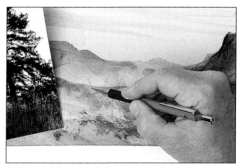

A Pencil sketch will guide the brush
Using a fine pencil, lightly sketch in the outline of the trees.

137

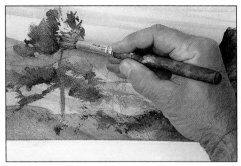

Build the foliage with a stencil brush
You might find it easier to build the foliage as an abstract pattern before establishing the trunk. Load a suitable "split-brush" (I used my favourite stencil brush) with a suitable color and start to establish the broader areas of foliage. I used a mixture of Yellow Ochre and Payne's Grey and wanted any foreground foliage to read as a muted silhouette against the warmth of the valley in the fading light. While the foliage is still wet, drag the trunk out of it using the edge of the brush.

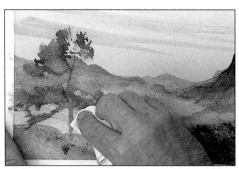

Lift with tissue to soften the tree
Quickly dab or wipe away some of the foliage and trunk with a tissue. This prepares the tree for the mid-toned shadow-areas to follow.

Shadow foliage with a stencil brush
Reload the brush with a darker mix of the green (or use the Phthalo Blue/Light Red mix) and create shadow areas of foliage (which will start to give the tree three-dimensional form). Compare this stage with the last to see the difference. Use this dark wash to block in the simple shape of the distant trees before moving on to the next stage

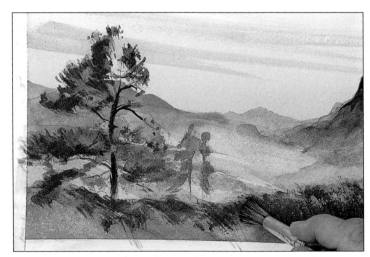

Shadows will unify tree and grasses
Use the stippler and shadow wash to unify the tree and foreground by continuing the shadow toning down the trunk and into the grasses beneath.

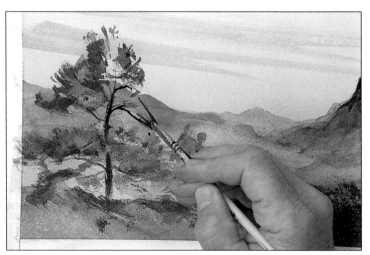

Add branches with a finer brush
From this point on it's easy to add branches and even twigs to the tree (especially those silhouetted against the gentle light from the sky and ranges).

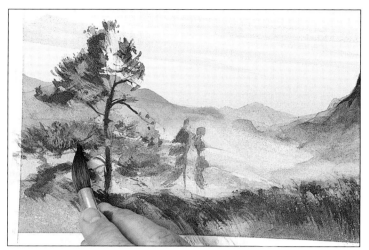

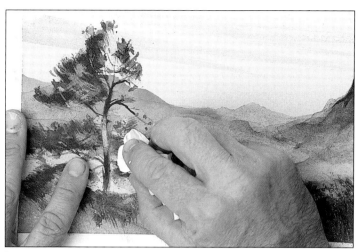

To find out where you are, what to aim for, and what comes next, refer to the reproduction of **EVENING LIGHT** in the **"Fold Out and Follow Me"** guide inside the back cover of this book!

Color will enliven the foliage

Because the dark foliage now seems almost monochromatic, enliven it here and there with a little Cobalt Blue. When wet, this may seem too strong; but, it will recede when dry.

Now counterchange the trunk

Using a wet brush (a firm hog hair is ideal), disturb the pigment which creates the dark trunk and lift that area with a clean, dry tissue. This lighter element will break the monotony of the tree silhouette, especially if you lift it where the trunk crosses an area of dark foliage.

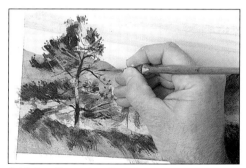

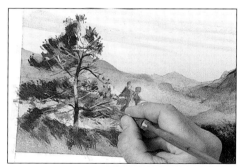

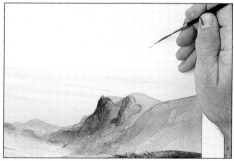

Add details with a fine tipped sable

A fine tipped sable is ideal for detailing with dark pigment. Work over the entire tree creating whatever details you want with two simple processes: 1. Lifting to create light details on a dark background, and 2. Painting them with dark pigment where they are seen against a light background (in other words, "counterchange").

More bodycolor

Using a fine brush apply bodycolor to the trunk of the tree BUT before you do so compare the result in my painting after doing this with the effect achieved simply by lifting. I think that the lifted area is more subtle than the bodycolor which appears contrived. But there's no going back!

Add an eagle in flight with a fine brush

Using a rigger or other fine brush paint a soaring bird with two simple strokes. Practice this on a scrap of the same type of paper first, and then only attempt it when you are confident that your hand and brush know what they are going to do. (This bird is almost invisible at a distance; it's a reward for those who look closely at your painting.)

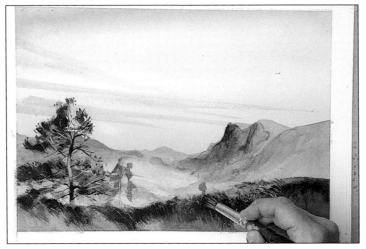

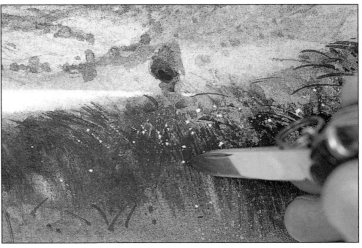

Add a tree to balance the composition
Create a simple tree shape in the distance to lead the eye of the viewer away from the massed foliage and back into the composition.

A knife blade creates crisp whites
The blade of your trusty pocket-knife is perfect for lifting crisp whites here and there: blades of grass from the foreground, tiny branches from the tree — even the suggestion of insects or flowers just catching the light in the depths of the grass (which is otherwise very dark). In my zeal to demonstrate for the camera I've probably overdone this effect.

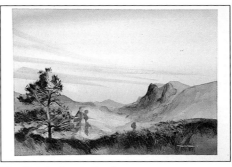

Remove the tape
Thinking that I had finished the painting I removed the tape, peeling it carefully away from the painted surface. (Peeling it towards your painting could tear the picture!) But then . . .

The finished painting?
. . . having peeled off the tape I was not happy with the total absence of very light areas and so decided to create a lake in the valley. If you want to try this too here's how to go about it. As you'll see, my first attempt was not successful and so I eventually "resorted to the knife", as they say!

Cut paper to position the lake
Cut a piece of white paper into the shape you want your lake to be and position it to consider the effect.

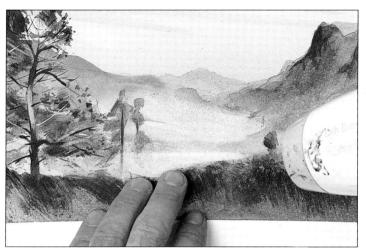

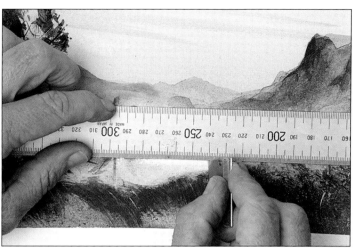

To find out where you are, what to aim for, and what comes next, refer to the reproduction of **EVENING LIGHT** in the **"Fold Out and Follow Me"** guide inside the back cover of this book!

Use a blade to scrape back the surface
I first tried taping above the lake, wetting and wiping back to lift the pigment. I then dried it thoroughly. This effect was subtle, but did not give me the light that I wanted.

And so I used a ruler and blade to scrape back a band of light just near the far shore.

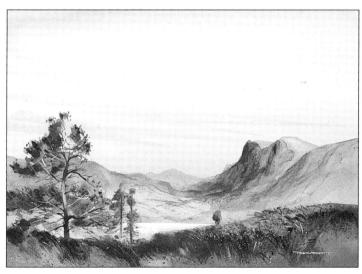

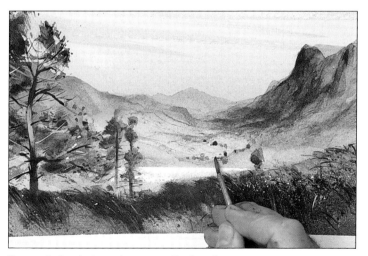

To increase the play of light I scraped back a larger area of the lake. This was much more satisfactory and gave me the area of white I wanted. Would you have lifted it? Remember, this is not a real valley, but made up. As its inventor I can take risks, introduce lakes, trees and mountains where none exist, change the lighting — do anything I like. And I carry responsibility for the risks I take. Success and failure are constant companions, and the result is often open to debate!

Suggest simple tree shapes on the far shore
Load a small sable with a little of the darker gray and create a few trees on the far shore. Remember, they only have to suggest trees and probably won't need any detailing.

FINISHED PAINTING, COMPOSITIONAL ANALYSIS

There are a number of different ways you could analyze this composition. It's even easier to see this in mono.

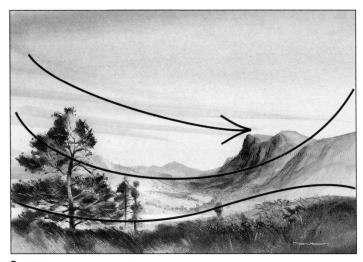

Curves

As a series of sweeping curves converging on the face of the mountain.

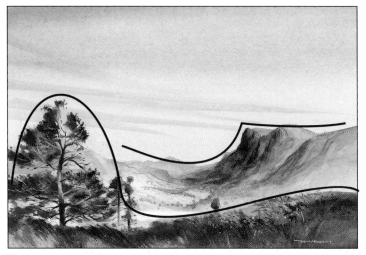

Planes

Three basic planes — all treated differently.

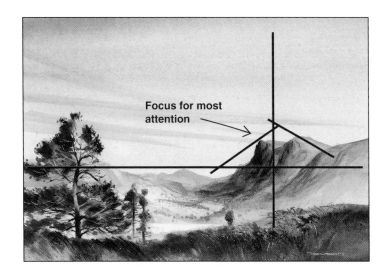

Focal point

In conventional analysis the bluff is a logical center of attention because of its prominance on the Golden Section.

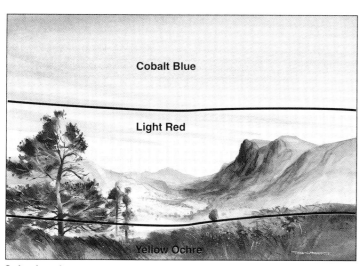

Color bands
As a series of color bands which unite the different elements (established with the first few brushstrokes) in Cobalt Blue, Light Red and Yellow Ochre. Although the Yellow Ochre been suppressed by the heavily shadowed foreground now it does still warm the lighter tonings within the grass and on the far shore.

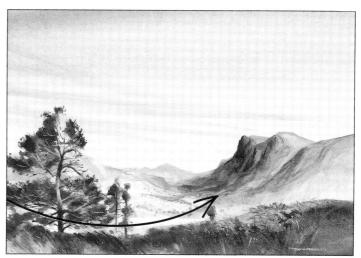

Upswept
The trees marching in (and receding towards) the bluff lead the eye upwards towards the soaring bird.

To find out where you are, what to aim for, and what comes next, refer to the reproduction of
EVENING LIGHT
in the
"Fold Out and Follow Me"
guide inside the back cover of this book!

SUCCESS OR FAILURE?

It would be so much easier if things always worked out in the way that we planned them but, as you know that is very often not the case in watercolor — especially if you relish the risks involved in creating your landscapes as you go along.

In the gallery pages of this book you'll see paintings that are representative of those I exhibit and sell (my "art" you might say).

However, this book has not been about painting like me or anyone else; it's been about YOU DEVELOPING YOUR OWN CONFIDENCE AND SKILL to paint original creative landscapes from your own imagination. If I can do it, so can you! "Evening Light" and the other demonstrations are simply there to take you through a few creative and technical processes which I hope you'll find useful in your own watercolors.

I also hope this book has encouraged you. There's room in the watercolor world for you to take any technical and esthetic direction you choose. So become an original! Work with the medium in your own way. Adapt, absorb, modify and utilise my suggestions or anyone else's in any way that works for you!

ABOUT THE AUTHOR

Tony Smibert is one of Australia's best known watercolorists and teachers of watercolor. He trained at the National Gallery of Victoria Art School and Melbourne State College, Australia and taught art for many years before moving to Tasmania to establish a studio and paint full-time in 1994.

He has held more than 35 solo exhibitions and shown throughout Australia and around the world. He is represented in numerous private, public and corporate collections.

An accomplished traditional watercolorist Tony has a particular interest in the 19th century English School. In 1997 he was invited to lecture and demonstrate J.M.W.Turner's watercolor technique at the Australian National Gallery in conjunction with a major exhibition of the great English artist's work.

In recognition of his long term interest in Japanese art his minimal watercolors have achieved a unique level of recognition in Japan where his paintings recently inspired a range of traditional kimonos by a leading master. The resulting collaboration was covered by the media world-wide and the resulting kimonos were shown in many countries.

At yet another end of the artistic scale, Tony's abstract watercolors are attracting attention around the world and he has been invited to hold a solo exhibition of abstract watercolors at the University of Salzburg's prestigious Gallerie Forum West in Austria.

But all this is not the subject of *Painting Landscapes From Your Imagination*. Although Tony is, by definition, an artist who is taken seriously by the art world, he is also a gifted and dedicated teacher. "This book is not about my own approach to art", he says, "it's about what other people can do easily, with a little help and encouragement! Nobody knows how much talent they may have until they start painting and then, how much creativity they might have until they start exercising it. I've been helped by a lot of people. Nothing gives me more pleasure than to share it around!" Already well-established as the popular author of numerous articles on art, including the acclaimed *Watercolor Apprentice* and *Watercolor Road* series in *Australian Artist Magazine,* and best selling video series of the same name, Tony's ability as an artist and teacher comes through in *Painting Landscapes From Your Imagination,* which combines information with thought-provoking conceptual material.

Tony Smibert and his wife, printmaker Carmel Burns, work from a studio/gallery which looks out over the mountains at Deloraine in northern Tasmania. They have two children, Olivia and Grace.